Momento:
On Standing in Front of Art

Jeffery Donaldson

Copyright © 2023 Jeffery Donaldson

All rights reserved. No part of this work may be reproduced or used in any form, except brief passages in reviews, without prior written permission of the publisher.

Edited by Shane Neilson
Cover image by Koyamori
Cover and book design by Jeremy Luke Hill
Proofread by Carol Dilworth
Set in Linux Libertine
Printed on Mohawk Via Felt
Printed and bound by Arkay Design & Print

LIBRARY AND ARCHIVES CANADA CATALOGUING IN PUBLICATION

Title: Momento : on standing in front of art / Jeffery Donaldson.
Names: Donaldson, Jeffery, 1960- author.
Identifiers: Canadiana (print) 20220484589 | Canadiana (ebook) 20220484600 | ISBN 9781774220764 (softcover) | ISBN 9781774220771 (PDF) | ISBN 9781774220788 (EPUB)
Subjects: LCSH: Art appreciation—Psychological aspects. | LCSH: Antiquities—Psychological aspects. | LCSH: Art museum visitors—Psychology. | LCSH: Art museums—Psychological aspects.
Classification: LCC N435 .D66 2023 | DDC 701/.15—dc23

 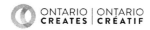

Gordon Hill Press gratefully acknowledges the support of the Canada Council for the Arts, the Ontario Arts Council, and the Ontario Book Tax Publishing Credit.

Gordon Hill Press respectfully acknowledges the ancestral homelands of the Attawandaron, Anishinaabe, Haudenosaunee, and Métis Peoples, and recognizes that we are situated on Treaty 3 territory, the traditional territory of Mississaugas of the Credit First Nation.

Gordon Hill Press also recognizes and supports the diverse persons who make up its community, regardless of race, age, culture, ability, ethnicity, nationality, gender identity and expression, sexual orientation, marital status, religious affiliation, and socioeconomic status.

Gordon Hill Press
130 Dublin Street North
Guelph, Ontario, Canada
N1H 4N4
www.gordonhillpress.com

For Tana Dineen & George Matheson

Contents

Preface	vii
You Enter	
May I Help You?	3
Threshold	5
Slow Time	7
The Vestiary	9
Enter, the gallery	11
Empty Rooms	13
In a Word	15
You Move About	
The Mannequin, the Tree, and the Altar	21
I Stand Before You Now	23
Crossing the Divide	25
Directive	27
Up Down Over and Across	30
You Are a Brush	33
Silence and Slow Time	36
Speaking Up	39
Being in the Way	41
Angels Coming Near	44
Gallery Going	49
Memento mori	53
Play	55

You Attend

Waiting	61
The Tree	64
Eros and Undies	66
A Space for Response	70
Caves of Making	73
Rendezvous	77
The Hawthorn Bush	79
Little Parlor of the Fishes	81
Jeweller's-Eye	83
Empty Bowls	85
The Waiting Room	87
The Watch-watcher God	90
Take a Load Off	92

Something Happens

Not bringing the Impressionists into Focus	97
Tomb Supplies	100
If you have eyes to see with	105
A Bridge is a Lie	106
On Being Watched Back	108
Working with a Painted Palette	109
Face and Field	112

It's All In Your Head

I Like What I Like	117
The Seer and the Viewer	121
The Reflection of Moonlight	123
Being Beside Yourself	124
Thinking about Thinking	128
Fictions Among Fictions	133
I Seen the Little Lamp	135
The Little Patch of Yellow Wall	140

You Leave

The Gift Shop	147
Street Crossing	149
Way Out	151

Preface

I have a brain like a pinball machine. Distracted by its own lights and bells, the little ball never gets anywhere. It makes for challenges. Those closest to me have had to resist the temptation to give the whole contraption a shake. At the same time, I don't always think of shifting attentions as a deficit, nor of hyperactivity as a disorder. Remember what Oscar Wilde said: take what everyone says is "the trouble with you" and cultivate it as your best promise. Wandering focus and restless energy can often be the truest sources of other-how, generators of possibility, dynamos of what-if. In any case, I can hardly be surprised if art galleries have been all my life a kind of antidote, a source of stillness and calm.

 Trouble is, I can go too far (or is it not far enough?) in the spirit of scattershot. I can end up skimming the surface, know a very few things about a broad range of topics. Hence the risk here. I earn my bread thinking about poems, not paintings. For one thing, I can't draw: even my stick people look awkward and forced. I did read my share of art theory in graduate school and carried E.H. Gombrich's *Art and Illusion* around with me like a Bible. But I am not an art critic and never studied art history.

 Ten years ago—in the midst of other projects—I found myself writing notes, little vignettes, about memorable paintings I had seen, where and how I had seen them. They started to accumulate. Before long they began to look like a manuscript in waiting. In my impatience to see what they were, I sent them to friends and editors. Peter Sanger was generous with his attentions and caveats. Tim Inkster sent it around to his art readers. It was all too scattered and disorderly (like a visit to a gallery?), naturally, to make much of. I laid it aside and years passed. All the while I

had this idea that I might adapt my unruly montage to an actual argument. How is looking at a painting like reading a poem? At least here I might be on surer grounds, comparatively. The iconic everything-at-once aspect of a painting, the formal and imagistic unities of a poem, the sense of address and encounter in both: the similarities are suggestive enough to make the differences revealing. The remnants of the tinkering I attempted in this direction are still evident.

In the end, while there were (as you'll see) poems on my mind, I found that the moments of gallery encounter began to speak for themselves and form the kind of narrative that we associate with story, with (as Philip Larkin quipped) a beginning, muddle, and end. Even a quest romance! At the same time, the idea that looking at one painting is like reading one poem began to recede (somewhat) before a further intuition, that it was the larger context of moving around in a gallery that felt to me like moving around in a poem. Inside both larger spaces—the poem, the gallery—you encounter images. You stop here and there, you pick up impressions as you go: moments of revelation. Did that mean that my series of vignettes on visiting galleries and museums was a kind of prose poem? I would only interfere if I started getting scholarly about it.

It was my friends Tana Dineen and George Matheson who first suggested to me that the manuscript I'd been fussing with actually had traction almost as it was. Tana talked to me about how reading my vignettes helped her to think about gallery visits generally, how we move through them, what we look for. She showed me that there was after all a kind of quest-romance hero lurking in the shadows, one who fulfills her promise by passing through a series of encounters on her way to a certain revelation of herself as the hero she'd been looking for. I couldn't have wished for better.

So here it is, all the same, this work, hanging (like a painting?) between various conceptions and initiatives. In any case, I hope it will be enough like a gallery visit for different sorts of readers to find their way, choose their attention, concentrate on or skip accordingly, as their own deficits and disorders, their own skills and desires, recommend.

You Enter

May I Help You?

Frame the scene. You know where you're going and you know how to get there. The streets are crushing and loud; this bus, this subway connection, these stairs up into the daylight and onto the street. You find your way to the entrance, line up, purchase a ticket, flash a card. At the coat check you agree to leave behind some of what you normally carry about you. You pass a threshold and move more timidly now, as though you'd been shifted into neutral, coasting on momentum. You glance at a map perhaps, get your bearings. You choose a room, almost randomly, and enter it, approach an object under glass. Perhaps a third-century Roman oil lamp. Or you gravitate towards the first painting you see, a miniature landscape by Constable or, at the Art Gallery of Hamilton (AGH) near my home, perhaps an impressionist piece by William Blair Bruce. You stop in front of it. You stand there. The room is very quiet. It was quiet before you got there and it is quiet now, though you can hear low voices around you, as though they'd been scattered about to give you something not quite to hear. You stand there.

If your first response is anything like mine, you say to yourself: "I should be feeling something." It is as though you found yourself before a distant acquaintance, someone you weren't expecting to meet. You ought to have something to say. But also not that, for this is simpler. The object is passive, inert, unintending. It isn't waiting. It is just there, there where it was yesterday, and where it will still be tomorrow. It does not seem to notice you. No one will feel slighted if you simply turn and walk away. You feel a kind of lethargy in the knowledge, an almost imperceptible heaviness. At the same time, you're thinking, this

is something I have approached, and, now that I've approached it, it is strangely held out to me.

You feel nudged towards it. A moment ago, you were full of purpose. You had somewhere to get to. You parked, you paid for a ticket, all to get somewhere. That was your purpose. Now that you have stopped, the idea of purpose makes you feel somewhat *thrown-forward*, as in a car that has braked suddenly. The swell of a momentum passes through you. You attend to it, or you ignore it, but it is there. A momentum towards what? What on earth are you doing here? What are you looking for? What is supposed to happen in a place like this? There are lots of other people doing more or less the same thing, so you needn't feel out of place. Everyone is standing and looking. You're left to yourself. No evident pressure, no expectation. It would be odd for attendants to come up and ask if they can help you; odd for you to reply that, no, you're just looking.

Threshold

Look into the eyes of the people arriving and the eyes of the people leaving: is anything different? I remember sitting in the first gallery that visitors enter at the Musée d'Orsay in Paris (through the entrance into the grand open space, up the stairs to the mezzanine on the right): at the time it was filled with a collection of Bonnards, some of my favourites. I spent so long there that I got to watching other people as they entered, knowing that most of them were just coming off the street. You could tell. The room had a different, somewhat more disorganized or flustered feel to it, as though it were a part of the gift shop, compared with some of the rooms farther in. Visitors would enter, a little too fast on their feet, like people stepping off a crowded subway car. Pushed from behind. They hadn't slowed down yet to the pace recommended by the curious rooms. Most seemed thrown off by a sense that the space was telling them something about how to move around inside it. I had this odd idea, as they turned too eagerly round and round, that they were like a mess of cars on a winter highway when they hit black ice: going too fast without any traction.

We do, of course, walk into museums with expectations. We will see things, be moved or amused, learn a fact, have an experience, fill out the afternoon pleasantly, get something from the gift shop to remember what happened here, what we *did*. That something might feel more real to us than the visit itself, for it is ours to keep.

There will be other people there, moving about for similar reasons, looking for similar things. Those two, for example, have been standing in front of that pencil drawing for five minutes. Every once in a while they say something to each other without taking their eyes off the picture. They seem terribly wise. There's

another man with an audio guide. He is listening very carefully. When he finishes listening, he moves on. Another circles the room at a slow even pace, a pace so even that he might be in the seat of a revolving restaurant. Still another sits on a bench in the middle of the room and studies the floor plan. If we were all made of plaster, we would be figures in a George Segal sculpture, plucked from everyday moments in a museum gallery, examples of ourselves.

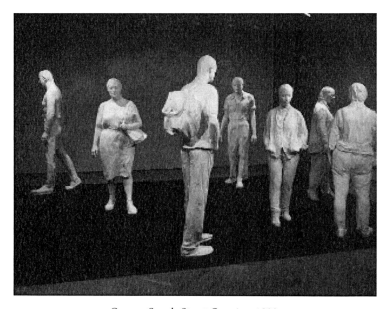

George Segal, *Street Crossing*, 1992.

"Expectation" comes from a Latin word that means to *look outwards*. For what? What I have ventured here is not so much an answer as a kind of empathic meandering. You might think of the sections that follow as so many gallery rooms, small spaces with one or two ideas about galleries hanging in them, one or two ideas about the pictures they contain. You can look for a while and then move on.

Slow Time

I am mystified by daily life. I don't understand it. Our stubborn ordinariness, how we live with it, how we embody its routines, its compromises and dulling seductions. I mean the incessant minute-to-minute stuff that is impossible to write down, because writing it down turns it into something else. Virginia Woolf wrote in her diary that she liked to record what she was going to make for dinner—sausage and haddock for instance—because writing it down made it more real. It is why, seeing someone in a movie walk along a sidewalk, looking bored to tears, can leave us aching to walk along a sidewalk feeling bored to tears.

Most of the time we are not where we are. We disappear, like pictures hung too long on the same wall. Automatons, we ration out to ourselves only enough consciousness to feel that someone is at the helm. In place of awareness we turn on a kind of autopilot which does little more than register the reality of time. So much of what we do in a day comes with an indelible time signature, the foreordained necessity and habit of putting one thing after another. Our having to get here, our needing to be ready for such and such. Next and next, and soon, and later, and already, and not yet, not yet. Who has time for anything other than time? Most of the time, it is really time itself that seems most alive, the vital energy, the wakeful god. We do for it. We are its minions.

How patient we are with haste! We give it space to move in, we scurry along. We use the metaphor of keeping up, but really, it's an odd expression. Think of it: how can you fall behind where you are? You would think that fact might infuse our strides with more confidence, opening out into a space and time we already

inhabit, taking to heart more and more of what it is. But we don't. We empty the present. It is poured from us. And, in turn, we wade restfully into the incessant flow of tweets and sound bites as into a warm bath. The devices we throw ourselves into, our iPhones and their enabling apps, are busy making things easier, quicker, more efficient, less troublesome. They are the time-god's talisman. We have become terribly patient with the cloud of hastening that we wander in. We walk into its offices and malls, our homes, our bedrooms. We explore it. We sit with its imperatives. We say to it, show us everything you are.

Have you ever noticed that time only seems to go slowly when you are forced to *move* slowly, or even keep still? A traffic jam, a line up, a highway detour, a muddy field, or my favorite, a "waiting room." In certain spaces, our sense of a hurrying momentum is blocked, often with considerable frustration: the idea of "next" is withheld. You want to break out of the space and get moving again.

It may seem counterintuitive, but we manage our time best by managing the spaces we enter and move through. We enter most of the places that slow us down only by accident or necessity, not as often by choice. There are exceptions, like parks and gardens, with their winding paths that circle about themselves, leading you back in a sense to where you already are. Nature is transformed into a waiting space, its arbours and wistful topiary become signs of an intentional abeyance. Churches are still popular this way, some of the slowest spaces in town for the secular and the religious alike. You walk in. People are sitting about in pews, evidently with great purpose. They are keeping still. It seems interesting, this choice to slow the body down for a moment. As churches become tourist attractions, we attach to them an outdated myth, that the people are keeping still because they believe in something that isn't there. Nice to see them there though, keeping still.

The Vestiary

Ah, we've moved too quickly, as always, and forgotten the coat check. We tend not to think of coat checks as part of the museum experience proper. They are as uninteresting and merely serviceable as the ticket counters and washrooms. Often enough, as you walk in the main doors, an attendant will smile you over in their direction. You are not yet ready to enter. You must go there first.

Galleries and museums keep a great deal of storage out of sight. Usually only a small fraction of a total collection is spread out in the open rooms for our perusal. In storage, the art is kept safe, collapsed into condensed spaces—as into so many zip files—until it may be opened out, allowed to breathe, exhibited. So too, there is the coat check, an inner storeroom of sorts where things are placed, not to be seen, but to be held during your visit's *meanwhile*. The coat check is a kind of museum, a collection of things. But they are from outside, things that somehow don't mix well with the art or with the rooms where the art hangs. You leave a part of yourself. "I must travel more lightly in this place. There are things that I usually keep about me that I won't need here, that will be an incumbrance, for myself and others." You hand things over. You take a claim ticket, an Ariadnean thread, so that you can find your way back to them afterwards.

Behind the coat check counter, unnamed, inaccessible, is an inventory of objects for a kind of still life, props for an outdoor street scene, a costume storage area for the improvised theatre piece you've been playing in most of your life. The play is in *intermission.* You have stepped out from the great proscenium arch, from the vast stage flats of outside weather and traffic. The costumes you have worn—what role

did you play today: mother of two? tourist? accountant? starving artist?—must be returned to storage. You are just yourself again. You need only your plainclothes. You return to the real world. You enter the museum.

Here in the vestiary among the long racks, the wall hooks, the cubby holes of various depths and heights, is life in abeyance. There is nothing here worth exhibiting. Coats, scarves, hats and toques, umbrellas, boots and overshoes, knapsacks and bags, their uses laid aside. They have numbers attached to them, unreal names. They are the ghosts of the people who wore them. They line up in the order they arrived and wait patiently for redemption. Objects in coat pockets are unfidgeted. Why do they hang about, these coats and hats, these spectres that cannot be uncovered for they are but coverings themselves? Why do they wait so patiently? What are they thinking of? Whatever brought them to life in the "real world" has moved on and they are left to whisper of it. The real world has become, as Wallace Stevens might have said, "a body wholly body, fluttering its empty sleeves."

Enter, the gallery

Museums, in the middle of things, are spaces apart. You have a museum anywhere you put an object on a shelf, anywhere you can say, this thing is doing its work just being what it is. The first gallery that I ever visited as a child, without knowing it, was the corner of our little dining room in north Toronto, where my parents had hung a rather ostentatiously framed print of John David Kelly's "The Battle of Queenston Heights": two British and American armies advancing at one another in a cloud of cannon fire, flags on high, General Brock in the lower right half, already fallen—there is the bullet hole in his red jacket—pointing his sword towards his charging soldiers and crying out "Onwards York Volunteers!" I know the painting hung in the dining room, but the dining room falls away. I am just standing there looking. I am General Brock, I am the doctor who tends to his wound, I am the Mohawk rushing to join the battle. Worlds apart.

Everyone has a place in their home where some small or special thing is *put out*. Think of the double meaning there: both "presented for your attention" and "set apart from other things." Think of how intimately these little museums are at home in your living space, how our living spaces become homes partly because they have these little museums in them.

There is something about museums themselves that show what a print on a wall or an object on a shelf already are: secular spaces that you can move around in for their own sake. Spaces apart. Granted, we might not see it. It is quite possible for us to move through a gallery as we move through most other spaces, blindly, restlessly, thinking we need to get somewhere in them, not knowing where, but bustling to get there.

Room leads onto room and our passage through them, often thanks to a curator's careful forethought, can make a story of sorts, chronological ones, thematic ones. They seem to be about following a thread, a line, getting through things in a certain order, as one would say of life outside the building. But there is something about museum and gallery spaces that runs counter to these gentle momentums. They are more spatial than temporal. Our experiences in them are more metaphoric, and therefore more like, say, the reading of a poem than a novel. They don't say, "Start at A then proceed to B." They say "A and B." Part of you wants to move about more haphazardly, and does. You sense juxtapositions, things having to do with one another. Wherever you look, you find your eye drawn to the centre of a world that emanates in all directions from that point, without necessary reference to what comes before or after it. The rooms are sonnets. The rooms are haiku. The paintings that hang in them are the images that fill them out.

Empty Rooms

The rooms you find in galleries and museums are not empty in the usual sense. But they lack furniture and objects that have specific everyday functions. No appliances, no TVs, no machinery for making things, no desks for people to work at, no checkout counters. There is the occasional seat, of course. But the exception almost proves the rule so far as noticing how little seating there is. Emptied of familiar purposes, the gallery space is a room for looking.

There aren't a lot of rooms like this. The same might be said of car showrooms and clothing stores, except that the things you find in them are for sale. Their display is a means to an end, not an end in itself. They are arranged so as to compel a purchase. Now I don't have a lot of illusions about the museum as cultural institution, sitting up eagerly for affluent feeders. Museums of course are economic institutions that have a stake in staying open, making money, if not openly for profit, at least to secure the kind of future that "profit" symbolizes in the general economy. Their seeming to be there for their own sake (the paintings and the visitors alike) can be a front for people with money and leisure time enough to pay for the privilege of supporting it and thinking well of themselves for doing so. But at least, as a symbolic exception, museums show, however inadvertently and at the *same time*, that there is a rule to prove. Wherever you find objects on public display that are not obviously for sale, you have something that you call a museum. By this same rule, nature would be a kind of museum, though only of course when it isn't being exploited. How thin the line between a museum and a quarry.

Empty rooms suggest not inventory storage, but a clearing for display. Physicists know that no space is really empty, though space has to *appear* empty in order for light to pass through it, that is, for us to be able to see things in it at all. Illumination in this sense depends on emptiness, and there are entire religions based on this kind of negative theology. I like the idea that a culture—perhaps even in spite of itself—says to you as you enter a museum, "here is an empty space for you to look at things in, a space whose seeming emptiness is an invitation, a space to look *into* and look *through*. Move about here as you please."

Are the walls actually walls? Are they not more like windows, floating holograms, that give onto otherwheres? Bruce Chatwin wrote of his discovery among aboriginal Australians of the "Songline," a performed ritual in which people would mark their territory by walking about its perimeter chanting a song or telling a story. In a gallery space you can intuit something like this faith in art to identify and *describe* spaces that we may call our own. Our eyes are drawn to the surrounding limits, the markings that make our movements intelligible to us and more real. We become a kind of spinning dynamo, a centre of awareness, whose emanating attentions gyre to the outer reaches of where we are. And of course the windows in the walls, the paintings themselves, are throughputs, openings that give onto pastures, valleys, streets, distant prospects, faces, and minute still lifes, all side by side, no two alike.

In a Word

These daydreams apply to both galleries and museums, and, insofar as they do, I don't want to make fussy distinctions between them. They are, in brief, both places where you will find objects of cultural interest. But there are lines to be drawn. We wouldn't think to find a whole building called *The Gallery of Natural History*, though in a *Museum of Natural History* there may be something called the *Dinosaur Fossil Gallery*. Nor would we think to purchase a local lithograph from anything called *The Locke Street Museum*. What do these words mean?

The word "museum," you can hear it already, comes from an ancient Greek term μούσειος, from μούσα, muse, meaning a place holy to the muses, a building set apart for study. One such building was an institute for philosophy and research at Alexandria. Plutarch offered a working definition:

> In olde time they builded the temples of the Muses, that is to say, houses ordained for students, which they named Musaea, as farre as they could from cities and great townes.

Turns out that you don't actually need to leave a city to find such areas at a remove; you need only pass through a doorway, cross a threshold. The original impetus for a museum, then, was ideational, connoting a place you went in order to exercise the mind, just as a gymnasium was a place you went in order to exercise the body. Something *happens here*, and this is the place for it to happen. You could, theoretically, go out into a farm field, draw a circle around yourself with a stick, do some careful thinking in it, and call where you are a museum.

The other inference, you'll have guessed, has to do with inspiration. The muses in classical culture were goddesses of deeper awakenings in literature, science, and the arts. That their individual dossiers ranged across both the arts and sciences is telling in itself. They represent a marriage of intellectual and cultural concern that is preserved still in the mandate of most museums. Seven of the muses carried various portfolios in song and drama broadly defined, but the last two, Clio and Urania (who saw to history and astronomy respectively), broadened the reach of these knowledges that were deemed to be most important at the time.

Inspiration. You go to a museum not just to perform a certain activity, like looking and thinking, you go there to have something *happen to you*. In literature at least, you don't visit the muse: you wait for, or implore, the muse to come to you. Milton's invocations to the muse at the beginning of Books I and III of *Paradise Lost* marry the flavours of modesty and almost apocalyptic presumption:

> What in me is dark
> Illumin, what is low raise and support;
> That to the highth of this great Argument
> I may assert Eternal Providence,
> And justifie the wayes of God to men.

"I'm going to channel some God here... but I can't do it myself!" Only a poet of epic ambition could manage this unique, and I'd venture quite genuine, humility. The tradition of invoking the muse in poetry should be of interest to any person struggling to get things done. Is inspiration something that comes to me from outside, or is it already within me and merely waiting to be realized or *drawn out*. Do I need to wait for it, or do I need to *get somewhere* for it to happen? If I simply do some right thing, will it all come to me, or is it only in my power to create the fostering conditions of inspiration, an inviting locale? Of course, anyone who has struggled long enough will tell you it is a little bit of both, passive and active at once. You *do* something, and that doing something opens a space into which something may *come to you*. What better than to have such buildings in our societies that capture, and *house*, just this understanding of the makings

of culture. You enter a space and, as you move among its rooms, things begin to happen. You visit the museum and then, very quietly, find that you yourself are visited.

If "museum" is a place where you do something, "gallery" is the space itself, its architecture or design. The term has been borrowed from the French *galerie* and Latin *galeria*. That a gallery should be first a kind of space, rather than the strict purpose of one, opens it up to a variety of uses. That's our key to its broader reference today. What kind of space is a gallery? It means, says the *Oxford English Dictionary* (OED), "A covered space for walking in, partly open at the side, or having the roof supported by pillars; a piazza, portico, colonnade." Let's note two suggestive features: 1) a gallery was normally built on the outside of something; and 2) it would be typically used as a space where you walk, often around or between other spaces, a transition or passageway. Because people move around in galleries, it can make a rather convenient place to display things, *on the way*, as it were. Think of wares for sale in a marketplace where there is plenty of traffic. Here's a little comment by the Latin historian Pliny, describing a painted portrait: "This image of hers was set up in the great gallery or publick walking-place of Metellus." Understood in these terms, the attractiveness, or *draw* of the space falls in a different light. We didn't start moving around in galleries because there were lots of things there for us to look at. Things were put there to look at because that's where people moved.

Over time the focus of the word does begin to shift from a space to pass through to a space that exists expressly to contain or house a particular inventory. The purpose of a gallery—normally either commercial or aesthetic, to sell or to see—is still relatively open and flexible. Mind you, the inventory is still likely to be a work of art or an artefact, which is to say, something to look at. There wouldn't have been much point in putting out in those *galeria* things for people to use, like a butter churn or a thresher. The same principle explains why there are billboards on the sides of roads and not washing machines. There seems, then, to have been from the beginning something mutual in the relation between galleries and works of art whose purpose is to be seen.

That sense of shared accommodation is only enhanced when we think of the nature of art itself and what it can make happen: art as transformation, art as journey or quest. I like the idea, in any case, that while we move about in a gallery there is some residue of art's original *place*, and that it is art itself now that lends back to the gallery something of its traditional function. Art in a gallery makes it *as though* we were just passing through, *as though* we were in transit, moving between spaces, and could still find ourselves in a middle distance where anything might happen, and for that reason be very much *on our way*.

You Move About

The Mannequin, the Tree, and the Altar

When do you stand in front of something and simply look at it? I don't mean the business of everyday attention, your purposeful address to any tool at hand, like figuring out how to program the cable box, repair a bicycle, flip the omelette in your frying pan. I mean actually going up to something and looking at it. A map in the subway, perhaps, a directory at the entrance of a mall. But also, objects for sale: the blouse on the mannequin in a shop window, a watch in a display case, a car in a showroom. We judge them as examples of themselves that we can decide to buy or not. Then there are objects not for sale. A tree, a landscape, an altar in a church. We go to some things for information or guidance. With some, if they have done their work—the map, the blouse—the thing that happens next will be clear to us: we walk in a certain direction, we get out a wallet. With other things—the tree, the altar—the purpose is more intangible, the thing that is supposed to happen next less obvious. We have thoughts in front of them.

The moment in the gallery is unique, similar to these experiences, yet different. For one, and the point is obvious enough, the painting is not for sale. Art is bought and sold of course, but once the painting has ended up in a public gallery, we think of it as having arrived at the end of a journey, which is to say that it doesn't have farther to go. In its quest for a place uniquely its own, it has risen above the financial conditions that have shadowed it all along or borne it like a tide to this shoal. The observer, like a buyer, may feel inclined to judge the painting, but not in the interests of owning it in a material sense, a vulgar possession. Buying it would have nothing to do with "making

it yours." The museum metaphor for making something yours, of course, is the postcard in the gift shop, and you'll get there soon enough. As for the work itself, you can only possess it by becoming more deeply involved with it where it stands, seeing it, thinking more about it, committing to memory more and more of what it is, assimilating its moods to the life you take back out with you onto the street.

Museums are collections of things that are not for sale. The world of buying and selling goes on. And there seems to be a residue here of its effects. We sometimes talk of people coming here for what we call their "cultural capital," as though they were investment brokers for a kind of arty self-esteem, whose shares they will hock at twice their value next time they hold the floor at a dinner party. There may, of course, be folks to whom such attitudes apply. There is clearly nothing else here of capital value that you can take away, says the ideological skeptic, so it must be cultural capital that you come for. But it's a cynical place to start, disqualifying curiosity, intellect, imagination, soul-making, self-creation, before you're even through the door. In the meantime, the museum quietly insists on that very difference. There is nothing for sale here. Come and see.

I Stand Before You Now

Now you are inside. Here is your first encounter, a tiny plant fossil in limestone from the Mycenaean era. It looks like a pencil sketch by Audubon. You stand there. What now? When I close my eyes and think of someone saying "I stand before you now...," I find myself imagining a rather large, public encounter. A politician is on the hustings. A couple is getting married. Someone speaks into a microphone, cameras sparkling. When would you say something like this? It isn't just the preface to any old speech. No, it is a moment of self-declaration, of magnified disclosure. You are going to say something true, perhaps about yourself or about something you believe. Whatever is at stake in your relationship with your audience, this is the moment of its proclamation. "I stand before you now a convicted sinner!" Or "I stand before you now to say this government is committed to public health care." Or "I stand before you now to pledge you my troth." Not "I stand before you now to order some large fries," or "I stand before you now to talk about the weather." No, you declare that you are unusually present, that you are facing something (a fact, a rumour), or someone (a lover, a judge), and that your facing it directly and announcing yourself before it are what give the moment meaning. You want to be carefully understood, you want what you say to be here and now effective.

When we wander about a gallery looking at objects, we tend to think of ourselves as the audience, often for legitimate reasons, the ones who wait in expectation, have come to receive. But turn the moment inside out. The Pharaoh's amulet there under the glass is not a large audience, nor is the weathered

sheet of illegible 3rd century Chinese calligraphy a bustling marketplace shuffling in expectation of your next word. But what if you behaved or felt as though it were? There is the 19th century indigenous mask, waiting, like four thousand people, for you to say something. Should you say anything? The air is charged with expectation. You square your feet and clear your throat. You are within its hearing. What happens now will be on the six o'clock news.

Crossing the Divide

So this isn't just about a painting or an object, a Van Eyck portrait or an oil lamp, and what you might or might not make of it. It is about the moment itself when you stand in front of it. Your standing there has meaning. If I were to stand back from myself standing there, I would see a kind of tableau: a painting on a wall, a person standing in front of it: the essence of artistic encounter.

To be sure, most artistic media involve the familiar twosome of an art object and a respondent. An audience listens to musicians on a stage. A reader curls up in a chair with a book. As for the musical scene, there is in our imaginations often something more democratic and multiple, both among the performers and in the collective audience that takes them in. The simple divide is there—production and reception—but you have to depopulate the scene to find its singularity. You have that very singularity when you sit down with a book, but something of the divide itself is missing. The book is *in your hands*. You hold it to yourself, "curl up with it", we say. It is an extension of your own body.

The gallery scene comes at the relationship from a different angle. You have the momentary singularity: one person and one painting. And you have the strict, easily visualized divide between art and observer. A thing is offered. There is a yawning blatancy to it. It says, "here I am." And you approach it. Each advancing step is a metaphor for "closer discovery," "greater understanding." There may be barriers before you: a rope, a glass, even the frame of the picture itself in a discreet metaphorical sense. An actual or implied line is drawn. But your approach represents the *refusal* of barriers. There is in your simple facing forward a form of existential address, an openness to encounter,

a readiness to find. Be you focussed or distracted, be you excited or bored, no matter if you are looking at the painting through the lens of a camcorder, or listening to an audio guide, or talking indifferently to friends, you have become, just for being there, a metaphor for that most essential of encounters, a human being *moving towards* something that human beings have made.

Directive

Something dwells in a museum, and what dwells there is "at home." People come to visit it. But the rooms of a museum differ in at least one aspect from the rooms of a family dwelling: they are almost all alike. In a gallery, public space is multiple. The more we come together in it, the more of it we need to come together in. You move through essentially identical rooms, one after another: singleness of purpose.

This is a building where you come to wonder at things. Where else does one get this impression of hopeful and imaginative concern? Churches? Their different areas seem ranked in authority: nave, chancel, altar. You move towards a heart of attention. Like nature perhaps (where a pond over here is not ranked above a meadow over there), museums and galleries tend to be more democratic than hierarchical. You might guess by the flow of visitors in the Louvre that all roads lead to the Mona Lisa, but the room itself is no easier or harder to find than any other room. As Elizabeth Bishop says in her poem "The Map," "North's as near as West."

The metaphoric cousin of museum design is not the domestic dwelling, but the labyrinth. In Greek mythology, a labyrinth (as for instance the one that held the Minotaur at bay) was used to keep those who entered it from leaving. You became disoriented. A sinister purpose to be sure, in that light. We might find a museum's version of this in the earnest desire, expressed in membership drives and special exhibitions, that you will want to come back. But of course you aren't a Minotaur to be feared, and the museum is not a trap like an Ikea showroom.

Momento: On Standing in Front of Art

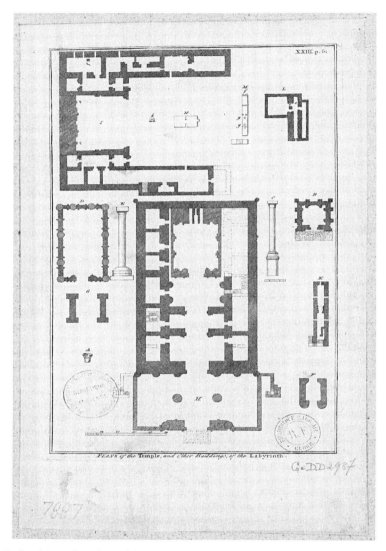

Richard Pococke, *Plans of the Temple and Other buildings of the Labyrinth*, 1743.

Most of the time in our lives we know where we are. To become lost is to lose time, wander pointlessly, fail appointments, miss out. On the other hand, getting lost in a museum, taking Robert Frost's "Directive" in the right spirit—"if you'll let a guide direct you / Who only has at heart your getting lost"—is a privilege,

a form of allowance, an education in itself. To become lost here is not to lose time, but to let the passing of time fall away. Looked at from above, labyrinths are a form of mandala, objects of meditation. You enter, pass through a series of seemingly identical rooms, turn to the left, turn to the right, venture upstairs and around. You forget how you got to where you are. You try to retrace your steps but make a wrong turn and end up somewhere else again. Better just to press on, see where it takes you. For all you know, you may be one turn from a street exit, or one step from the deepest inner chamber. Then you enter a room that you recognize; you've been here before. How did that happen? What is this place that you should find yourself so continually starting again? Then suddenly there rises before you a work that you know and were hoping to see. You don't know how you got here and wouldn't know how to track it down again. You were wandering. Did it find you or did you find it?

Up Down Over and Across

Arrangements of works on a wall express historical and ideological factors, as much as personal taste, from the colour of the wallpaper to the discreet placement of an Exit sign. One such taste involved a habit, quite common into the 19th century, of crowding paintings on the display walls from floor to ceiling. This was partly a matter of efficiency of course and is still a common enough feature in collections of all sorts. If the curator of the Paris Museum of Letters and Manuscripts had little else in common with the artists of the caves of Lascaux and Chauvet, we can at least imagine them groaning in unison: "where are we going to put all these things?" Space may not always have been an expedient in the efficient and sufficient display of art. No king of the 17th or 18th century needed to cram all his paintings into a single room, say, the library, but such was often the habit of the time. No doubt an aesthetic of "clutter" makes a point of its own, pointing to a quantity of riches just barely controlled by a collector's crafty design sense and wit, itself on display as much as the paintings he owns. There can be other impressions, of close relationships between paintings, between artists, or between artists and their owners, clusters of affiliation, even the sense of art being "everywhere you look."

The cluttered idea has become less attractive and desirable in modern galleries. Our models are classical. You have only to walk, say, among the artefacts of ancient Greece in the British Museum to see how the penchant for the monumental and the design of modern museums are at one. In fact, to look there at the twenty-foot reconstructed facade of the Nereid Monument is to intuit how self-reflexive we've become in our designs, where monuments house monuments.

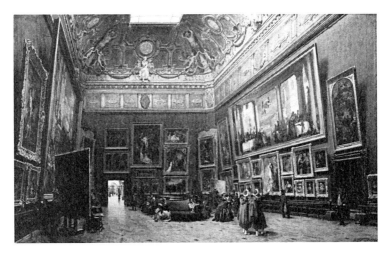

Giuseppe Castiglione. *View of the Salon Carré in the Louvre*, 1861.

I'm a product of the times. When I see a cluttered wall—with paintings hanging above other paintings at eye level—I feel an intervention, the sense in which a work has not been shown in its best light, allowed to be itself. I can't resist the feeling that judgements have been passed, geniuses ranked, certain canvases given precedence over others. The ones I can look straight at are "the good ones." The others looming above them are one wall space away from basement storage, and insofar as they seem *to say so* in public, may be better off there for the time being.

One or two feet between horizontally aligned canvases seems to be the agreed-upon measure of a work's independent integrity. You move along. You stop. "This is my spot," the painting says to you. "The panel here to my right names it for me." In one sense, the work is more democratically distributed. At the same time, this sort of arrangement can be controlling in its own way. We are invited to view works consecutively on a linear horizontal plain. We move along from one to the next in what is mostly a determined order (start where you may...). Horizontal narrative is favoured over a kind of free wandering of the eye in all directions, up, down, over, and across.

Is it not interesting that paintings themselves suggest more of an affinity with the cluttered wall, where the eye is invited

to move about, not only horizontally, but in all directions at once? This of course suggests in turn that the cluttered wall is like a single painting itself, a vast landscape of relating parts, and maybe that is its point. The collector is an artist and has arranged each painting in relation to every other, as though to make a further canvas for the eye, a new world equal to the many smaller ones that populate it. Curators are artists, but in their linear arrangements they are not so much painters as story tellers. They begin ... "once upon a space."

 A last thought there. In his studio at Le Cannet in southern France, the painter Pierre Bonnard would hang up his canvases in every empty space available on the eight-foot wall near his window. He would work on them all at once. Stirring up a particular shade of yellow, he would apply it to a sunset on this canvas, to the edge of a book on another canvas five feet away. You witness a general becoming, gradual as bricolage, where everything emerges into its own with everything else. Viewers in a gallery are artists of this sort, their moods are the colours they work with. While you're in such and such a mood, should you scoot over and apply it to this other canvas, which in your opinion could use a little more of that feeling?

 Is it worth noting too that the artists at the caves of Lascaux and Chauvet were both painters and curators at once? They painted their pictures *in* their galleries, *on* their walls, where they were at home. They found an empty space that could be filled. The gallery was their canvas and its permanent walls the family show space. They painted up, down, over, and across.

You Are a Brush

I read in the Tate Modern that Max Ernst would get a painting started by doing rubbings over various surfaces and then develop into figures and scenes whatever "came up." Run a piece of charcoal or pastel, for instance, over a sheet of paper laid on top of a flat stone. Let the patterns you find suggest to you whole landscapes, buildings, people, faces. You join the lines, you fill in the spaces.

The romantic artist Alexander Cozens began his scenes from nature with ink blottings. You make a kind of Rorschach test by splashing some ink down on a sheet of paper, next folding it in two, pressing the sides together, then opening it again. Up pop mountains, valleys, rivers, sublime magnitudes deftly culled from inky accidents on a page. You can get past the obstruction of the blank canvas and trick yourself into painting. You begin *in medias res*, not so much "in the middle of things," as "*into* the middle of things," with a sense of directed energy or momentum. You are thrown into the midst of a work by way of caprice and serendipity, those inspired muses. It is access to the wellsprings of the unconscious that one wants, where vague outlines coalesce into strange and wonderful variants.

After suffering a period of severe writer's block, I remember talking with the poet Eric Ormsby. He told me that he had gone through a dry spell that lasted for years and that he got writing again by allowing himself to write "baby talk." You put down whatever nonsense comes into your head, the stuff you would be embarrassed to look at again, never mind show to other people. The practice helps you steal past those inner border guards on the blank page. To be *already writing* is the writer's version of

the Rorschach primer, a letting up into consciousness innocent and random associations, without anxiety, to see what might be made of them. Baby talk: to say whatever comes into your head. The genius of children is that they don't overthink, or edit themselves, or get in their own way. The insights of innocent spontaneity, like unfolding an ink blot and saying what you see. What you find yourself saying may surprise you, even sound like wisdom. Out of the mouths of babes.

To be *already but not really* looking as you move around would be a viewer's equivalent in an art gallery. Your intentionally unintentional steps, your blank pressings-forward, are so many ink blottings. You have no idea where they will take you, but you can trust that they will start to look like something.

Alexander Cozens, *A New Method of Assisting the Invention in Drawing Original Compositions of Landscape*, 1785.

Viewers have as many choices in how to set out among the works before them as a painter has in confronting the blank canvas. There's our analogy. Be it moved that the viewer's first look is like the artist's first brush stroke: same anxieties, self-doubts, the same nagging echo "not now, not now." The looming blankness.

Picture yourself as an artist, painting your visit to the gallery. Some visitors may be quite deliberate and executive. They know what they are looking for and they know where to find it. They are a little intimidating in their purposeful strides to one particular place. It is as though their visit had been, as with portrait painters, commissioned. They have a job to do. Then there are others, the majority of us, who are there merely to discover, to experience, to find ourselves in the midst of a we-know-not-yet-what.

You are a thinking brush. Where to dip in? How long to wait? Where to apply yourself? How heavily, how lightly, with what tone or mood? Do you scatter yourself freely about in broad swaths of looking, or concentrate on one small area of detail, little dips and dabs in a corner? Then you notice something, an image, a subject, the whim of an idea, a wisp of colour curious in itself. Once you see it, you build on it. You find it elsewhere. You step into new rooms and it jumps out at you. You extend it into more and more of the total workspace you move through. You catch the scent of a motif, you follow it. You make connections. You are working more purposefully now. You make confident choices, go this way instead of that. You are not rushing, but efficient, executive, inspired. You know where to go without knowing where to go. The connections you make are becoming lessons learned, new relationships, insights, revelations. You are discovering as much as making, making as much as discovering. Slowly, you begin to sense that the space that needed to be covered—sometimes very little of the whole gallery—has been covered. To continue now would be to spoil the effect. Spaces you stayed clear of this trip show in a different light beside the spaces you concentrated on. They too are meaningful. It all holds together, the knowns and the unknowns, the visited rooms, the rooms left to themselves. Your visit is the narrative thread that binds the whole. It was your eye that went over it, your moving thoughts, your thoughtful movements, that bound it together. Your work is done. Thoughtful brush, you lay yourself aside.

Silence and Slow Time

Mixed in with, or not far from, the display case of ancient Greek bowls and amphorae, might be a collection of classical urns: funerary and ornamental urns, urns for oils, perfumes, and cosmetics. Given the enduring nature of the clay used, it isn't surprising that its surfaces should have proved a popular medium for artistic expression. Their spherical shape provided a unique canvas to work with, different from flat or linear surfaces in the way they invited stories or scenes to come full circle, if you like, end where they have begun. When you look at a picture on a flat surface, the elements are laid out in space and you let your eye pass over them in any order you wish. Of course, you need time to look over the entire work, but there is a sense of stillness in the image itself. There is something about how the painting is laid out all at once before you, to take in "at a glance," that complements the sense of "now and forever."

 Any artwork that cannot be seen all at once, on the other hand—a film, or a piece of music, a dance—defers more to the temporal dimension of our space-time continuum. Strangely enough, sculpture and other three-dimensional objects belong partly in this group. An urn cannot be seen all at once. To turn an urn in order to view it from all sides, or to walk around it yourself, is in a peculiar way to participate in the passing of time—like moving the hands of a clock—in making time pass, even to dramatize that passing. As you turn the urn, or as you turn around it yourself, you become the godly enlivener, the one who has in her hands the power of making visible one-thing-after-another, and who uses that power to breathe a living unfoldingness into the still experience.

We want to say that *at the same time* the figures on the round surface are motionless and fixed in eternity. Which is, among other things, what John Keats wanted to do. In "Ode on a Grecian Urn"—one of the finest examples of "coming close to looking" in literature—Keats visits just this puzzle of time. Like a viewer in a gallery, the poem "visits" an unspecified Grecian urn decorated with a series of tableaux, whose figures are frozen in time. This is not to say that the figures themselves suggest a motionlessness. Quite the opposite.

> What men or gods are these? What maidens loth?
> What mad pursuit? What struggle to escape?
> What pipes and timbrels? What wild ecstasy?

There is dancing, music, kissing. A lot of what is happening seems to gesture towards a goal, towards a moment of promise that promises just for being sought. The figures lean towards it. But their actions are incomplete and fixed in their incompletion: an unfinished motion's motionlessness.

> Fair youth, beneath the trees, thou canst not leave
> Thy song, nor ever can those trees be bare;
> Bold Lover, never, never canst thou kiss,
> Though winning near the goal—yet, do not grieve;
> She cannot fade, though thou hast not thy bliss,
> For ever wilt thou love, and she be fair!

But of course the characters *do* move around in a certain way. They move around the urn. We circle it in order to see where they go without moving. They wheel around and come back just as they were, with the surprise and bright expectation of children on a carousel.

Inside the urn, we can imagine, it is black and empty, inaccessible to the figures on the outside. A place where no one goes. The figures themselves own no special secrets. They are dancers or lovers, captured in the act of dancing and chasing. They have no particular in-sights, so to speak, no special access to the dark interiors they orbit. And yet we know, from where we stand, that the dark and empty interior is what makes them possible. It gives them a round world to turn on; it gives them grounds on which to extend their reach.

What about us now as we stand and look? Are we so different from the figures on an urn? Dancers and lovers, we circle about the work and admire it. The urn is the blank empty space that we revolve around. It holds us to it. There is a stillness in our movements. It is what makes our roundaboutness possible. What are we doing there? What do we *look like* when we *look for*? If we were to stand back and consider ourselves, we would see a work of art brim full of a secret emptiness, and we would see everyday figures like ourselves jostling around it, limited in their knowledge of that something at its core, but sure that it was their trying to stay close that gave to them a feeling of gravity.

Speaking Up

There is a name for a descriptive poem like "Ode on a Grecian Urn." It is called "Ekphrasis," a Greek term to designate any poem that is about a work of visual or sculpted art. It means "to make speak out." You can't pick up a book of poems these days without finding an example of ekphrasis in some form (guilty as charged), but the tradition is as old as literature itself, with exponents going back, for example, to Homer's account of the shield of Achilles in the *Iliad* and Martial's brief descriptions of *objets d'arts* in his *Epigrams*. As John Hollander shows in his book *The Gazer's Spirit*, an ekphrastic poem describes a work of art—sometimes quite intricately, as in Keats's example—but it does not fulfill its purpose in merely redescribing. It must *recreate* as well, fastening on one or another feature, cropping or enlarging upon it to expand on some unarticulated potential, make it "speak up." If the poem were not recreative in some form, why should we need it when we have the painting itself doing its own heavy lifting? The initiative of ekphrasis is based on the idea that something extra comes to the work when it is translated into a verbal form.

What I particularly love about many ekphrastic poems, including "Ode on a Grecian Urn," is that their approach to the work seems to be partly their subject. The speaker of Keats's ode stands in front of an ancient cup and says things about it. The poem itself, naturally, contains the scene of approach. It is as though the poem were a kind of room, a gallery space with a single work in it, where, if you entered the room, you would have nowhere to go but straight up to the lone work plainly offered there.

Now consider turning the whole scene inside out. The gallery itself now becomes a kind of poem, where things come to be looked at. Every visitor to a gallery or museum is a potential ekphrastic poem. Every instance of approach to this or that object, a bowl or a fossil, transforms it into what, for that unique moment, will be its conscious and verbal equivalent. For having done nothing more than enter and approach, you are the work's speaker. What you say now, let it be casual or indifferent or inquisitive or far-seeing, will be lines from an unwritten poem going round and round (*about* the object in every sense) to work themselves out. It will unfold as you speak. Knowing this may leave you wanting to listen to what you say, perhaps even make a promise to yourself that you should do so. You give it your word.

Being in the Way

The room is crowded at the Art Gallery of Ontario's special exhibition of choice Picassos from the Musée Picasso in Paris. We seem like particles bouncing randomly in a very slow-motion Hadron Collider. It is at moments like this that you are most aware of a gallery's version of the Heisenberg principle: to observe an environment is to change the conditions of the environment you observe. You will never know what a painting looks like in a gallery when you aren't there to view it. But in a crowded room, you are aware of the reality of other observers, yourself among them. I don't *always* mind. I am part of the traffic after all, and I don't want to be like one of those SUV hysterics in the halted fast lane, honking at everyone else for being there. And there are ways of thinking about it. Such a *commotion* of looking. All that attention and hubbub. What an occasion! The paintings are at their finest, brilliant, modest. "Excuse me, *Les Demoiselles d'Avignon*! How are you liking Toronto? What do you have to say to your admirers?" "Oh, I'm just so glad to be here." Revelations bursting, like cell phone flashes.

I'm not one of those who feel that a work of art can be used up in being overexposed to the public. People can stand around it forever, it will be what it will be. As Emily Dickinson says, "to multiply the harbors does not reduce the sea." At the same time, where space is tight, it is hard to get careful long looks at things. If you aren't at the back of a cluster with your own view blocked, you quickly become aware of yourself as in the way. Someone's experience of *The Woman with One Eye* is going to include the bald spot on the back of my head.

Momento: On Standing in Front of Art

I've never had the pleasure of seeing Caspar David Friedrich's *Wanderer Over the Sea of Fog* in the Kunsthalle, Hamburg. The painting dates from a period when artists were becoming increasingly aware of the place of the human within the natural order. For much of our history, we have been inclined to see the natural world as objectively *out there*, with ourselves apart from it trying to figure out what it is. Most paintings even now support the inference, where we put a frame around the art, set it there in front of us, and look at it. Lately, however, the lines between observing subject and observed object have begun to blur. We are more sensitive now to our own implication in the *nature* of what we see. The known universe is an expression of how we look at it.

So there is Friedrich's wanderer, in something more like a stylish dinner jacket than climbing gear; he finds himself on a rocky crag looking over a world of uncertain depths and contours, a world that he is both in the midst of and apart from. He sees one scene as an unselfconscious observer. We see another scene, with him squat in the middle of it. We see the world with the observer in it, with *observing* in it. We look at the wanderer's back. We observe his posture. It becomes, actually and figuratively, the main point. Everything in that painting—from the vectors of the skyline to the mists themselves—seems to organize around the observing act.

Friedrich is doubling up on the experience of looking that you yourself personify as you gaze. You, standing at the painting there, are a wanderer over a sea of mists. Or more specifically, you are a wanderer over to "The Wanderer Over the Sea of Mists." If you find yourself among a crowd of viewers gazing upon Friedrich's masterpiece, mimic the posture of the man in the painting, and know that you too are a wanderer over a *seeing of mists* in all your wanderings here. You may block someone else's view of Friedrich's sublime expanse with your bald spot, but at least you will have your tongue in your cheek.

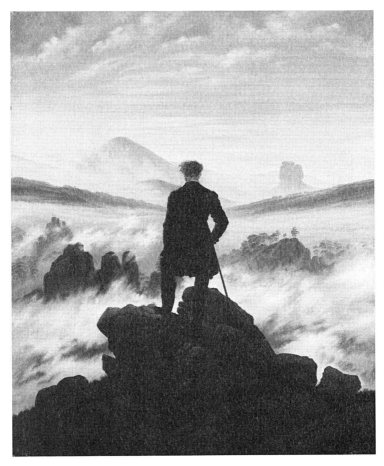

Caspar David Friedrich, *Wanderer Over the Sea of Fog*, 1817.

Angels Coming Near

At the Petit Palais in Avignon there is a particularly rich collection of paintings of the Annunciation, including Bartolomeo Caporali's easily recognizable rendition of this very familiar story, the angel Gabriel's announcement to the Virgin Mary that she is ... expecting. Perhaps more than any other story of the Bible—with the obvious exception of the Crucifixion, whose painterly possibilities stand at the other end of Christ's life—the Annunciation cries out for pictorial treatments. Something about them is mysteriously at home in rooms of pictures, but I'll come to that. The Biblical source is Luke, chapter 1. Gabriel descends to earth and announces to the Virgin Mary the advent of a saviour, to whom she will give miraculous birth. Mary reacts variously to the news, in attitudes that are known now as the five stages of response: Conturbatio/Disquiet ("She was troubled at his saying"); Cogitatio/Reflection ("And cast about in her mind what manner of salutation this could be"); Interrogatio/Enquiry ("How shall this be, seeing I know not a man?"); Humiliato/Submission ("Behold the handmaid of the Lord; be it unto me according to thy word"); Meritatio/Merit ("Blessed art thou among women," and "Blessed is the fruit of thy womb").

You can stand before an Annunciation painting and identify the familiar markers. First of course, you need a Mary. If the artist is depicting the earliest stage of her response, she will be reading, or sitting on a bench divinely cogitating at prayers, or otherwise thoughtfully putting in time. Whatever she is doing, we think of her activity as the clearing of a space, a making-ready, an inviting of the angel into the openness of who she is and what she represents. I like to think of reading

itself in this sense, and of the scene, as a kind of secular allegory of what can *happen to you* when you take the trouble to read. I also like the idea (though not for ordinary religious reasons), that what she would likely be reading is the Bible: not the New Testament of course, part of which is only being *written out* as the scene unfolds, but certain readings in her native Aramaic. This is another way of thinking allegorically about reading itself. Mary's reading there alone is what makes all that happens to her possible, a *foretelling* of the very visitation that otherwise appears to interrupt it.

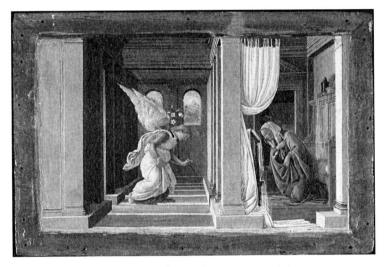

Sandro Botticelli, *The Annunciation*, 1485.

Mary is marked off in a space, an enclosure, that is entirely hers. She has a room of her own, Virginia Woolf might have said. Indeed, I like the idea in Woolf that every artist must enjoy the kind of imaginative space that reading itself represents. Often enough the canvas will be divided into two distinct halves: the half in which Mary moves, and the half in which the angel Gabriel appears. The divider can be managed with pillars, columns, arches, floor tiles, garden walls, shadows, imaginary projected lines, or almost anything that has two sides to it. The line between Mary and the angel is crucial. The angel has come from another world and this needs to be made clear.

The angel will usually have a set of wings, in deference to those more literal-minded among us who need to think of them as flying down from somewhere in the heavens. More suggestively, the painter may include rays of light, usually with a dove riding on them. These represent the holy spirit, the divine light of God that accompanies the angel and in a sense licenses its authority. The angel in fact would never *dream* of coming without the light at its back. You can think of it as a kind of letter of introduction under the royal seal. When coupled with Mary's secular enclosure, the light captures the spirit of what is most deeply at stake in these works, that two worlds, a world we live in and a world we can imagine or desire, come into close contact and change things forever.

As Annunciation paintings evolved over time, the nature of the light itself changed, becoming less and less strictly Biblical, more secularized, less dependent on a literal interpretation of the story elements. In Medieval renditions, the light can be so etched into the canvas, so gilded, that it is the most dominant presence in the scene. As you move through the humanizing Renaissance, you find the light becoming gradually more disembodied, more indistinguishable from mere daylight. As we move through the 18th into the 19th century, we find the scene becoming more secularized. The angel Gabriel himself will often disappear, or rather fail to appear (so shy do the spirits become in a scientific age), his place held now only by a glow of light at a window. Vermeer's various versions of a woman standing at an open casement—holding a jug, reading a letter, quickened by changes that the light carries into the room—are some of the earliest explorations of how to preserve a sense of divinity in a world otherwise secularized and emptied of angels. They are some of our very best Annunciations.

Annunciation scenes themselves would often come to focus on the virgin alone, portraits of a woman bathed in an otherworldly light, with facial expressions of expectation or hope. In these versions, the frame can represent the enclosure of art itself, into which an imagined light is poured, bathing the innocent face in a presence that comes from beyond the frame. Flip through the ads in today's fashion magazines, with a typical

model—mouth hung half open in divine, erotic bliss—and you'll see one of its more current expressions.

Why do Annunciation paintings seem so at home in galleries? There is again a kind of self-reflexive potential in these works, but I think there is much more to say about it than we have. Think about it next time you find yourself standing in front of one of these visitation scenes. What you can find there, whatever else comes to you, is a picture of the "visitation" that you yourself are involved in. It is what is happening to you. There is, on the one hand, Gabriel and Mary in the painting, "in there." On the other, there is the painting and you, "out here." You reflect one another. In both, there is a division into two worlds. You and Mary find yourselves in the ordinary world, ready for anything to happen. The angel Gabriel appears to Mary, and the painting appears to you, from across a threshold. They both appear from domains that are timeless and strange. A spiritual light passes through a window into the little space that Mary occupies. A created light passes through a wooden frame and bathes you in all that it foretells.

In the Annunciation scene, Mary is left guessing. How could such a divine presence appear out of nowhere in my little world? Is it not the same question you ask? Where am I? What is this place I stand in that has been made ready for something *to appear*, something that isn't a part of where I am? The rooms have been cleared of ordinary content and people stand about in them waiting for something to come to them. They look through the little "picture windows" that give onto possible worlds. They ache to know what is there. "Let something come to be in me," they say to themselves. "Or if it may not yet be, if it is only a sign of something yet to come, let me feel that what happens to me here will set something labouring inside me and bring new life to my world." And the paintings overhear them.

Standing before any painting, we pass through the same five stages of response that Mary herself does. Conturbatio/Disquiet: "What am I doing here?" Cogitatio/Reflection: "Hmm, this looks interesting." Interrogatio/Enquiry: "But what does it mean, what should I make of it?" Humiliato/Submission: "Wow, there is more here than I first thought." Meritatio/Merit: "Ah, now I see what

is happening; how wonderful!" A thought impregnates you. The silent painting says: "You there. Yes, you. Blessed is the fruit of thy womb."

Maybe it is at just that moment that the picture can turn inside out. Maybe you become the angel Gabriel, and the painting becomes the innocent, as yet unimpregnated, portrait of an expectant figure. You appear before it *out of the blue*. Your conscious thoughts become a kind of visitation, a fleeting revelation of what is already there, latent within it, waiting to be realized. A glance opens into it. Bathed in your presence, the painting comes to life, gives birth to something. "Bless you, angel," it says. "Let it be unto me according to your word." You look for a moment, and then take wing.

Gallery Going

The heading of this section gestures to the title of the well-known poem "Church Going" by Philip Larkin. In Larkin's original, the double-entendre is barely disguised and gives us two handy terms of reference for our own daydreams about the place of museums and galleries in the world. There is a visitation to a building (going to church) whose "contents" are explored, and there is the intuition of a change of attitude, or faith if you like, in those contents (churches are going…). The speaker of the poem enters the empty building timidly, notices a few details, moves purposefully to the altar—the natural destination—recites aloud from the readings there, pronounces "Here endeth" more loudly than he'd meant, and then, ending, leaves. An empty place of worship, a musty air, a solemn iconography, a language of endings, a departure and the inexorable feeling of being outside whatever the "frowsty old barn" was meant to hold: these are the terms of reference for Larkin's exploration of religious faith in the 20th century.

 Are museums the new churches? In some there are very definite altars, like the Mona Lisa at the Louvre, to which pilgrims make their journey to pay secular homage, to be cured of some unspecified cultural ill (the ill, presumably, of having not yet seen the Mona Lisa). They pour in. They come near. They snap their pictures, walk away cleansed. In most museums there is no altar, there is no cross near the far end that you inch magnetically towards and pray in front of. There are representations of these things, paintings of crosses and altars and other such religious "corners" of attention. But they are everywhere, and they don't have special status above any other point of interest in the

museum. They are subject matters. In the museum, whatever you come to visit, in search of your still moment or your window of revelation, it is apparently everywhere. There is no centre. That's what makes it less stressful for you to go looking for it.

The church altar, or the ark of the covenant in the synagogue, is at the opposite end of the spectrum of still moments. As with a painting, we know that they were placed to represent something. You go up to them and you have thoughts. Or you go up to them and perform a ritual, the ritual, that is, that represents *your going up to them*, your approach to what they mean and what they do. The approach is, in a sense, included in your commitment to larger meanings, even if those larger meanings are only realized in the act itself. We could say that every approach to a painting in a gallery is partly a desire to "come nearer" to what that approach means.

But we are not approaching altars or covenants when we approach paintings. The crucifix, the covenant: these are emblems, relatively fixed symbols that one approaches in order to approach what they symbolize. Religious spirit can be as ambiguous and multifaceted as the imagination that soars with it. But its iconography is more concentrated. The crucifix literally and figuratively *points*. It pours itself out in a certain direction. A secular painting has more of an in-itself quality—the elements of form and style, texture, mood, even subject matter. It is coy in implication, holds its cards to its chest, usually with less sense of a foreordained significance.

This becomes more complicated when the painted scene is of a religious nature (such as an Annunciation scene), but the distinction is clear enough. If you were to admire the gold tooling on the crucifix, the brush work in the flesh tones, the piece would take on something of this in-itself quality. And there may be an irony here: the religious painting becomes *more* immanent, with an inherent sacredness present in its painterly behaviours, the less it points to the presence of which it is the summoning symbol. The crucifix points away from itself towards the presence that *makes* it sacred. The painting pulls in the other direction. It says, "this, here, now." The sense of the numinous abides in the embodying form and points only more deeply into itself as but a harbinger of what it possesses.

The gravity of Larkin's poem is embodied in the attitude, the spirit if you like, of its speaker, who, as he moves to the heart of the church and then leaves vaguely disappointed, preserves a sense throughout of indifferent curiosity, a mood of questioning traditional purposes and reasons. the altar or the ark, we are meant, or invited, to feel engaged or inspired, with the strong recommendation of certain meaning. You might feel awkward walking into a church with so many devout praying at the altar if you aren't in the same frame of mind. You are intruding. In a gallery the sense of engagement with objects of attention is less stressful, and this can certainly be one of its attractions. You don't need to be equal to a particular kind of mindful energy. Here on the wall is just a picture of some flowers. Enjoy them, make of them what you will, and move on.

Museums and galleries often quite rightfully promote some idea of "come as you are." No expectation. But a wholly indifferent approach in a gallery comes at a price: a potential aloofness, an attitude of the merely relative may imply that whatever you do and think here, it won't, or *needn't*, have any real impact on your life. When Jews approach the covenant in a synagogue, or Muslims direct their prayers towards the mihrab of a mosque, they can feel a confidence in the presence of an already effective agent. The belief that earnest cogitations before it will effect real change in their lives informs their purpose. They recognize that something significant is at stake in their approach. Indeed, they approach with a very tangible expectation that, if you are attentive and open, you might leave a different person.

There are perhaps exceptions that prove the rule in art galleries. There is an entire genre of secular art where protest and exhortation are exactly the point. When you look at a vegan artist's exhibit of clothing made out of raw meat, you can feel aggressed with the implication of very particular truth claims. But when you feel a purpose of this sort, you may notice the rhetorical designs of religious iconography, the insistence on a message whose purpose is to send you out into the world with refreshed morals and intentions.

Fair enough. But if we were to hold the matching poles of these two magnets together—art and religious symbols—perhaps

their opposing energies would suggest valuable intersections of purpose and effect. We might appreciate how religious symbols can activate a spiritual attention that, like art, is open, relative, ironic, and detached; and we might notice how secular art, approached in good faith, can bring about real changes in people's lives.

Memento mori

You can spend a lot of time in front of a painting wondering if it is time to move on. Have I done this one? Shall we see what's next? The invisible tug that we often feel in front of paintings: not the tug towards it but the tug away, the unconscious tug you brought with you when you entered the building, the tug that whispers in your ear, almost beyond your hearing, "Are you not supposed to be somewhere?" We don't often confront that tug in our lives. Galleries are intensely about it. The painting appears. You look at it. Neither alive nor moving, it is not a part of time the way you are. It may give the impression, as you stand there, of snubbing the conditions of your being in front of it. But there you are, doing your best, wondering what is supposed to happen next: next painting, next moment.

 Still lifes are particularly interesting in this way. Still life: I've always been curious about the two possible lifes implied there, two ways of life, two ways of moving, that bear down on the "still," with its restless double suggestion of perseverance and fixity, continuation and cessation of movement. There is one particular genre of still life that encapsulates the still life of all painting, the *memento mori*. Remember that you will die. A skull on a desk, an old book, a pair of dice, maybe a burnt-out candle or an hourglass: objects presented, as it were, to remind you—what else?—to be present. The painting is already part of that timeless world it reminds you of. The sand in the hourglass—a figure of time quite actually running out—is fixed. Some hourglasses show all the sand in the bottom: time run out. Others show only a few grains in the upper chamber: the end is near. Still others show equal amounts of sand above and

below, a mere reminder of its presence *in medias res*, in the middle of things, make of it what you will.

Memento in English means, among other things, an object acquired or retained in order to preserve something in memory. It means memory itself, but also the things that hold memories. The skull serves as a memento of time passing in the same way that a souvenir serves as a memento of your visit. It is a present aftereffect. The aftereffect points you forward with a question: "What are you going to do now?" Every painting, "The Hay Wain" of Constable or Picasso's "Guernica," asks the same question.

Certain writers have introduced into the spelling of *memento* a suggestive variation, momento, that has taken on, as it were, a still life of its own. The substituted vowel carries us into the moment of the memento. A momento is a portion of time, a bucket of still water drawn from the stream. You pull up what moves so that you can hold it. But let's keep going. The real mystery of the word moment, the still passing, lies in its root, from Latin *movere*, to move. It is the same tension that we find in phrases, again, like still life, or keep still: a continuation of time and a freezing of it. We derive from *movere* the related term momentum, where now you are thinking of the forward push inside the stillness.

Standing in front of art, you are in the moment and the moment has a momentum. Where will it lead you, that immeasurably small distillation of force, intensity, ardour? What is it about the moment in front of a still life that leaves you feeling the magic and puzzle of all paintings? You are much alike, you and the painting there, with its hourglass and its dice and its fallen petals. It says "stay here, stay a little longer, just for now." But it also has its own momentum, the one that nags at you too, the one you live with, the one you will go with. For just a momento, the question "Aren't you supposed to be somewhere?" falls away. You stand where the moving on is already included.

Play

I was at the Pompidou Centre in Paris with my daughter Cory, who was a feisty ten at the time. I was looking for my favorite Bonnards and Vuillards. Mischievous creature, when she noticed me zeroing in on a particular painting, she would sneak around between me and it and then leap up, leap up repeatedly. There would be no confusion over who was the real show. She was playing and I loved it. A gallery room for her was a kind of playground, one that came with strict instructions as to what you could touch and not touch, but a playground all the same. Children remind us that play is as natural as breathing.

In his seminal work on the play-factor in human culture entitled *Homo Ludens*, Johan Huizinga draws a very broad circle around the vast array of play practices in our lives. Work, he writes, is the exertion of energy for a particular purpose. Play, on the other hand, is the exertion of energy for its own sake. The for-itself quality of all art makes it a primary expression of *homo ludens*. Often enough, the very idea of art for art's sake gets it into trouble with thinkers who hold that the highest human behaviour has reasons that lie outside them. Beyond painting, writing, sculpting, dancing and their like, we have the familiar institutional forms of play: competing, sporting, gaming. But then come the subtler expressions: thinking, reasoning, legislating, building, loving, pursuing, and of course joking. The circle of the serious becomes very small indeed. Huizinga shows that there is very little activity in adult life that is not aligned with the play factor in some way. How great was my surprise then, coming to Huizinga's exposition of the plastic arts, to learn that he excludes the act of looking at art as a form of play. He even excludes the

work of painters themselves: "the very fact of their being bound to matter and to the limitations of form inherent in it, is enough to forbid them absolutely free play and deny them that flight into the ethereal spaces open to music and poetry" (166). But he is quite down on the act of looking at their work, at least so far as play is concerned.

> If therefore the play-element is to all appearances lacking in the execution of a work of plastic art, in the contemplation and enjoyment of it there is no scope for it whatever. For where there is no visible action there can be no play.

To be fair, Huizinga's definition of play does draw lines, so to speak. To be play, an activity must be voluntary, outside the norm, and enclosed within its own configurations of time and space. The difficulty with a visit to an art gallery, Huizinga would argue, is that one is not outside the norms of practical movement, of milling about, of going from thing to thing in ordinary time. This plays into the assumptions that many folks make about visits to art galleries. That it is very serious. That it is work. No scope for visible action. You would think that the pretend element in painting—is it not outside the norm, enclosed in its own configuration of time and space, the very heart of pretending? —would alone qualify it as a form of play, but it seems not.

As children know, pretend is the greater part of what we are. We dress up. We put on faces. I suppose, then, that this is partly about letting out one's inner child. Not pretending to be an art critic, but pretending to be a child! Pretending to play, until the play comes true.

But back to Cory's shenanigans at the Pompidou. In his theory of romance narrative, Northrop Frye talks about the "exultation of the hero" at the end of the quest. Exultation, from the Latin, *exsilire*, to leap up. The prefix ex- gives us the up, but also, literally, an out. After the hero of a quest story has passed through the final trial, separating the worlds of good and evil, she is exulted. A leaping up, a leaping out. But where is that energy coming from? Is it we who exult on the hero's behalf, lifting her up, or the hero who, being who she is, rises out of the world she has wandered in? Just so, there is the painting and there is me.

Which is the hero, the exulted one? There is rejoicing, a leap, a getting carried away. Cory was only doing what the painting itself was already doing and what I was trying to do in response to it. Coming between it and me, she was showing me how.

You Attend

Waiting

There is, quite actually, a kind of waiting at the heart of attention. The French *attendre* is at the root of both words: *to stretch, to turn one's ear towards*, becomes *to carry your thoughts in the direction of*, and finally, *to expect an arrival*. Both are related to the concept of listening. Waiting is a form of listening, as is attention. Listening is different from hearing. It is to hearing what looking is to seeing. When you "turn your ear towards" something, it doesn't mean that you will hear anything. Listening is a getting-ready to hear. Of course, certain things will become audible because you have listened for them. But you cannot make yourself hear something just by listening for it (nor make yourself see something just by looking for it). If you are not listening, you may not hear. There is a middle distance, not between hearing and not hearing, but between listening and indifference.

The Bemberg Collection is in Toulouse, where I spent a marathon day in the Bonnard room. It is amazing how paintings can change and come clear when you sit with them long enough. Bonnard's "Scène de Rue." I thought that there was an odd cloud of smoke in front of the mass of trees sweeping across the upper foreground.

Then after a bit I saw that it was the sky showing through a break in the trees that recedes into the distance. Not just that, but also that the trees on the left side were not all up front, but formed the laneway of a mall that receded back into the canvas. A mere case of *trompe l'oeil?* Something more than that. It isn't so much that your eye has been tricked, but that with time it has quite actually seen more deeply.

Momento: On Standing in Front of Art

Pierre Bonnard, *Scene de Rue*, 1894.

There are two ideas of how paintings make their impressions on us. There is what Percy Bysshe Shelley might have called the "fading coal" experience of a picture (from his theory of creative inspiration in "A Defence of Poetry"). You enter, look about, and then you see it, the best painting in the room. It draws you to it. If it is an especially powerful work, you'll let out a silent or even dimly audible "mmm." You keep looking for another minute or so, you move up, you stand back, but somehow nothing quite matches the flush of first seeing. Not that you begin to like the work less, but only the first frisson stays with you. You wander off before too long, looking for the next buzz.

The other approach needs a biological metaphor: painting as seed perhaps. It takes root. It flowers. No matter how impressive

you find a work at first, it is always less than it might become if you give it time. Not much happens to a painting, in a painting, in the first minutes. When you approach a picture, you want to think of yourself as a gardener. You get down to the ground, you work the soil, break it up, turn it over, push in a seed, pat it down gently. Your eyes are gardener's hands. I like to think that all paintings of nature, whatever particular fluorescence they happen to depict, are also metaphors of *looking in progress*, a fecund and fruitful gaze. They grow on you.

Or another analogy: you don't look at a painting the same way you stare into blank space waiting at a bus shelter. But you wait with the same purpose and patience, the trust that *something* will arrive if you keep waiting. The painting is the bus that comes. And it comes because you had decidedly been waiting for it.

The Tree

On an evening walk you come to a beautiful poplar rising by a stream. You stop and take it in. Something has come to you, unexpected, offered by chance. The sense of encounter is more casual, less pressuring, less *intended* to do something. That is one of the things that makes a chance discovery in nature so special. Rare is the person who comes into view of a tree and says to himself, "Now what the heck am I supposed to do with that?"

Nature is the unoffered offering. You are its serendipitous discoverer. Your movement into and through the environment helps you to feel at home there. Surely this is part of what happier gallery experiences can be, a forest of accidental encounters; sudden surprises come upon as you wend your way. But the corollary is instructive. There would be something almost comical in seeing a man walk deliberately up to a tree in a field and stand at a suitable distance from it to take it in. "I have come to look at you," he says to himself, "and now I am looking at you." It would be the exception that proves the rule, for the man will have turned the tree into an *objet d'art*. And in fact, this is part of what happens when you have your favourite oak tree to photograph or your favourite panorama on the hill crest: "look at my lovely tableau."

In front of the tree we tend to feel more confident, filled with a response that comes naturally. At the same time, we might be less certain that the tree is there to have thoughts *about*, or that it is there for any reason at all. It's complicated. Standing in front of a thing, full of purpose, you might feel frustrated; but if you don't approach with intention, the thing may sleep forever. The gallery encounter meets you halfway: its meanings are at

once elusive and inviting; they inspire a curiosity and a desire to attend. At the same time, no matter how bewildered you may feel, you are nevertheless certain that the work is there for a reason, is there *for you*. That sense of confidence may be at the root of why we sometimes feel that trees in nature, as soon as we see them as beautiful, are there for a reason as well.

Eros and Undies

Yes, the boxers shorts at Bloomingdale's are for sale and the statue of the naked god Eros among the Greek antiquities is not. But is that the end of it? I get confused. If a store manager took down all the price tags from the racks of designer camisoles for a day and invited you to enjoy the merchandise for what it was intrinsically, would Bloomingdale's become a museum? That depends ... perhaps it might. If you stuck a "50% off" sign on that bust of Cicero, would the museum become a department store? Almost certainly. Go to Hixenbaugh Ancient Art on East 81st Street in New York, and you may find in one of their attractive vitrines an Etruscan vase selling for as little as $4500, a steal. It does get rather complicated. I can certainly imagine a rack of g-string underwear on display at the American Textile History Museum in Lowell Massachusetts, at the end of a row of inviting evidences that included medieval chastity belts, 19th century French pantalettes, and mid-western flannel long johns with a trap door. Historical interest.

But I'm looking for something more experiential here and am trying my best to avoid the word "consumer" or its variants. If you took a person standing in front of that bra rack (for our purposes, would this person's gender even matter?), froze her in her attitude, picked her up and put her back down in front of the statue of Eros, would she seem out of place? Would there be something about her posture, her *address*, her deportment in front of the stone god that would betray our switcheroo? Or the other way around ... if we froze our gallery visitor and plunked her down in front of the Calvin Klein stockings, would the store manager become suspicious and call security? There's

a version of this in literature that I sometimes like to try on people. You're at a restaurant. Across the room are two tables of four guests each, both far enough away that you can't hear the conversation. At one table, a person is talking about what he did on the weekend. At the other, a person is reciting a poem from memory. Would you be able to tell which was which just looking at them?

Is the browser among the lingerie closer to the rack than the museum visitor is to the sculpture? She'll reach out and finger the material, examine the straps, size up the goods. There is no imaginary line there between observer and observed. Of course in the museum, any man or woman who nestled a hand under Apollo's chiselled package to feel for its girth will get a quick escort to the exit. So there's that. But I rather like that notion of "sizing up the goods." It draws the two scenes closer. There is a particularly fine example of Eros among the antiquities at the Royal Ontario Museum (ROM) in Toronto, and I often like to visit it. When I stand in front of the statue, I am "sizing it up" to be sure. I admire the lines, the surprisingly realistic paunch, the detailing of the thigh muscles. I stand back to take it in, almost as one might if a beloved were to model a bra later at home, when it was no longer for sale. But of course one can also get up close to an ancient bust of Alexander, check out the long curls, the fetching dimple on the chin. Are we stuck?

I'm not sure. I'm picturing the wanderer among the racks of unmentionables, the peruser of classical roman busts. I still think I can discern a different involvement. There is in the shopper a curiosity about types and styles, but no real inquiry as to what the things are intrinsically. The bras are useful and the shopper has an immediate practical stake in which one will do the job, given her body and personality. For the museum visitor nothing quite so definite is at stake. She is less likely to wander off miffed that she couldn't find anything she liked ("Excuse me ... don't you have any statues here with arms?"). Her engagement with the objects she confronts has to do with their exemplarity, and she is open to a variety of examples, to find in each one something curious to value. The skivvies are not exemplary, either in what they represent, or in what they

are. Socks do not say to you, "I represent socks," or even "We are socks" (how much more interesting shopping would be if they did...). They simply are what they are. It is not reserved or reticent. They mean what they do. I'm thinking of an exception that proves the rule. Should there happen to be bras on display in the street windows at Bloomingdale's, they would indeed be examples of themselves. They would say, "here's something of what you will find in the lingerie section if you'll come inside." But then they would not be for sale.

Consider the corollary. Walking into the gallery of Greek antiquities, you wouldn't say "Hey, there's Eros!" You would say, "Look, there's a statue of Eros." It is a representation of the god Eros, and this particular specimen at the ROM is an example, in its form and style, of such representations as exist elsewhere. The statue is not identified with Eros. It *represents* Eros. It is identified with what it is. Indeed, the statue's not being the same as what it represents is a large part of what makes it so interesting. Eros is here and not here (would you say the same of the bra?). You are drawn nearer. What draws you nearer to the bra is your need of a bra. Eros is a kind of imaginary content, almost in the way the contents of those grundies are only imaginary, at least until you put them on.

One last thought. If, in your inspection of the lingerie, you should happen to find a flaw, a loose thread, a stitch gone awry, you would reject it. As for flaws in statues, I still remember the frisson of surprise I felt when I first saw the back of the Eros sculpture at the ROM. The original wings were missing. The holes that were left on the back shoulder blades had been plugged with cement and the general repair had left the shoulders and back looking bruised. As I stared, the damage said more to me about the wounds that Eros has suffered than any seconds in the lingerie department ever could. A relic of passing time, its dreams, its flights of imagination and fancy have been long since cut off—by accident, by resentful malice?—leaving it bitterly committed in the end to its actual weight in stone, so utterly holding it down, and to the single job now left to it of showing us what cannot be bought for love or money.

Jeffery Donaldson

Torso of Eros, 3rd-2nd Century, BCE.

A Space for Response

Why is it that in galleries of contemporary art people feel freer to say what they think? Look at the people wandering around among the stone cairns, the city plumbing laid out in rows, the clothes made up of dried grape leaves. They're having a ball. They giggle and whisper. "What the heck is that?" They take it in. They say "yes," they say "no," get a better look from the other side. They are good detectives, not afraid to say how they feel about what they see, suspicious perhaps, even doubtful, but not afraid to talk about it. Every contemporary gallery—whatever else it contains—seems filled with metaphors of our response to art in general, metaphors of what happens to us in front of the small ancient antiquity, in front of the medieval painting of the crucifixion. Viewers walk around the work as though it were an idea. How is it that these galleries, more than most others, invite a conspicuous engagement, whether positive or negative? We seem to move around *inside* a space of response.

Of course, in contemporary galleries, space itself is uniquely involved in the installations they house. This is not the case everywhere. Traditional paintings are small. Even the largest 18th century canvas is far outsized by the room we find it in. Almost any room could house it. The relation suggests a kind of indifference, not an insulting one, but one in which this is "the sort of painting" that shows in a gallery and this is "the sort of room" that it hangs in. The room itself, in a sense, is looking the other way, and is meant to.

Of course, most contemporary art gallery rooms can accommodate most contemporary installations indiscriminately, so there may still be something of the "bring it on and I'll hold it"

attitude there. But these rooms are unquestionably different. There tends to be more empty floor space, for one, and the ceilings are usually higher. Some of the spaces at the Tate Modern in London are as big as airplane hangars. The inference is hard to miss: space is *cleared*, opened up, boundaries are breached, ideas of *reach* and *extent* seem on display. Space itself becomes meaningful, a participant in the experience, a fund of possible resonances.

It was some time in the 19th century that paintings first broke out of their frames and went exploring. Their frames had been quietly reassuring. Whatever fell inside them was art, no matter how estranging or tricky. Whatever fell outside them was the real world. Every frame was a kind of classical proscenium arch, outlining an imaginative or theatrical space within whose bounds moved every manner of fiction and figure. You were defined as the audience by being outside it, peering in.

Our recognition of art *as art* is now more part of a process that takes us back to the roots of knowledge itself. Art is a meaning-making experience. I remember first scratching my head reading a comment by Northrop Frye, who said that a symbol was anything that was meaningful. Isn't that rather vague? But consider. A running shoe lies in a gutter and you pass by it for weeks without noticing; then one day someone points to it and says, I wonder how *that* got there? Suddenly, the shoe becomes exemplary, raises questions, points to something else, say, to the person who once wore it, or to the moment it fell from a knapsack. There is more to be said about it, and as it begins to mean something, an invisible frame forms around it. The moment you feel that an object, in a sense, is more than what you thought, it approaches the condition of art.

You can have such enjoyable debates in a contemporary gallery. Someone is going to look at that shoe stuck to the wall as someone's bad idea of where to store a shoe, while another will see it as a challenge to our notions of gravity and spatial orientation. This is why response itself now is so central. The work's *hold on you* will derive from your attitude towards it, the response it inspires in you, the manner of seeing that it recommends. It is why there is room now, in every sense, for performance art in its various expressions, art that quite actually depends on its being

experienced in time by an observer. It is why you can also have the sense, moving about in these rooms, of visitors meeting the work halfway, as it were. They "walk around" it, move forward and back. Henry James loved the expression: someone would say something to you and you would "walk around it." Your physical movements and gestures are metaphors for what your mind is doing at the same time. You become a *figure of response*. You can scrounge around inside yourself for some idea of what to do with a puzzling work. You reach, you implore. And as you do, the work itself may come nearer. Or not. This or that one may not be for you, but you'll have done your bit, giving something outside yourself the benefit of the doubt and granting for a moment that, where meaning in the world around you is concerned, all things are possible.

 I personally like to spend an equal time in the medieval and early modern galleries, trying to see them with the same incredulity. The people here, standing before a 15th century pieta, seem more solemn, perhaps having less fun, than their friends snorting at the arrangement of dried condoms hanging from a shoe box. That seems only appropriate. It is a difference in what they think they are supposed to look for. But that pieta may have an audacity equal to, if not greater than, that of the iPods lying at the bottom of the fish tank. You'll know the woman standing there has found it when she starts laughing.

Caves of Making

Given how they play with space and the boundaries of art, contemporary galleries return us to our prehistoric roots. There were no picture frames in Lascaux, no cordoning ropes at Stonehenge, no name plaques beside the hunter's decorated arrowheads in the caves at Chauvet. There, instead, were people simply discovering an inclination to generate meaning from the materials they found around them. Was there less anxiety, less fuss over *where to put this thing*? They had room for the products of their imaginations in the world they already moved in. Ancient art caves are special in that they were in a sense both a studio and a museum at once, a place where art was made and preserved. In the end there was little to distinguish the two impulses. Lascaux was, for all those intervening millennia, a kind of museum in waiting.

Lascaux Cave, circa 15,000 BCE.

Caves are secret places, hidden from the world. They run below ground and disappear from view. They have different, much older airs. Dark, spooky places. Like the mind itself. I think it was Guy Davenport, in his story "Robot," who first suggested to me the idea that Lascaux represents the unconscious of the human social animal. The story is a fictionalized account of the discovery of the Lascaux caves, with its 17,000-year-old illustrations of animals. With the help of their dog, two local boys chase a rabbit down a hole into the mother of all wonderlands. The meaning and value of their discovery is of central interest in the story. Dr Cheynier reflects that the caves are like arks for animal spirits and recalls "the inward brain" that sees in imagination. The earth itself, he muses, is a kind of inward brain that makes it possible for the landscape to dream of its animals.

The metaphor of the cave as a kind of imaginative underworld is an old one. W.H. Auden has a poem about his writing study called "The Cave of Making," about the inner worlds where creative spirits live. Physical spaces and mental states have been aligned at least since Plato, but the 19th and 20th centuries were particularly generous working out the implications. There is Freud's notion of the unconscious as a hidden, driving force that must be released for us to be healthy. Art itself, Freud imagined, fell on the side of repression, as controlling activities that attempt to keep scary energies in their place. Modern art had other things in mind, where surrealists and their ilk aligned themselves with those very dream spaces, whose release into the work of art was our saving grace. The inner worlds of illusion and the counter-rational became our actual means of discovering, uncovering, truths that lay *under*neath.

We didn't always feel this way. Plato's Allegory of the Cave took us in the opposite direction. Picture a scene of imprisonment. We are underground, chained to a floor, and face in one direction towards a wall. Behind us, unseen, our masters contrive to cast shadows on that wall by passing objects in front of firelight. Because we have never seen anything else, we prisoners, chained to look only one way, take the shadows as our reality and believe in them as the only truth that exists. Today, Plato would likely have used the cinema for his analogy. An audience faces in one

direction towards a screen, onto which are projected images of made-up worlds, and we are ... captivated.

As with the Surrealists, Plato used the cave as an underworld metaphor for the mind, and like the Surrealists he saw it as a world of dream and illusion. But for Plato this world of mere appearance was the world we actually lived and believed in, the world of chairs and tables and iPods and bridges. Above this cave of illusions was the real world, the upper world of abstract forms and prior truths, of which our everyday world was but a poor imitation. Our job, Plato believed, was to seek the truth. It would be as though one of the chained prisoners—a philosopher no doubt—had managed to turn around and see the masters, the shadow-makers, doing their shadow-casting thing. In short, he would discover *that* our world of illusions is a world of illusions. At that instant, he effectively escapes from the cave and rises into the true light of day. Plato was definitely on to something. We find the world around us so convincing, so intractable and there, and that's what traps us. What we lose is perspective. We forget that our world is to a large extent a made-up world, a world of powerful drivers, social and political and commercial forces whose masters keep trying to convince us that what they show us is simply how things are or must be. We become passive and cowed.

Yes, the truth will set us free. But where is the truth? I like Plato's idea that we live in a world of made-up things, illusions, and that we need to wake up and rise towards our better promise. But I also like our more current thinking—the Freudians, the surrealists—where we recognize that our minds, our five-plus senses, our mental processes, determine everything, including what we say is real and not real. In order to come nearer to "what is the case," we must make room for *all* the mind's activities, reveal them and understand them as such, see our made worlds as made worlds, just as Plato suggested. Enter the unconscious, enter dream spaces, enter the imagination and all it conceives and conceives of. Now we have *all* our resources at hand, not just logic and reason, but the whole of the human mind in all its creative and conceptual power.

We come full circle, back to galleries and museums, our modern caves. Stand back and look around. Inside the rooms, we see people milling about, staring at walls, staring into worlds of imagination and illusion, captivated. Outside is the "real world." The artsy types should probably get real, shouldn't they? There is plenty of that kind of thinking around. But there is one detail that distinguishes these galleries from Plato's cave: the visitors are not chained. They came here on purpose. They can move around, see in every direction. To move around and among works of art, see them from all sides, is to activate and embody a spirit of *everywhere at once*, seen for what it is, the whole of human creative activity at work. They see the created world as a created world. And that, even in Plato's terms, sets them free.

Galleries are caves, lower-world realms of the unconscious, dream spaces of the imaginary. They show themselves to us as *such*. The showing and the seeing as such is the point. Everything has turned inside out. It is now the world outside the doors of the museum that is the world of illusion, where made-up stuff is taken at face value for what it appears to be. We climb up out of that world by descending into cave-like museums and touch at the heart of what the artists at Lascaux already knew.

Rendezvous

People who visit galleries are often there in groups: social groups, family groups, couples. There is conversation, commentary, sharing, crowds swimming and floating in patterns like birds above trees. I've been part of all these, but I like going to museums alone just as much. I can focus better. My own pace, my own time. Oddly enough, however, when I am alone and a thought comes to me in front of a painting, I picture myself telling it to a companion, the one I love visiting galleries with, who isn't there. I feel myself saying it aloud to that person. It consolidates the thought, makes it real. We are creatures of social relation.

That tension between allowing yourself to be in your own head and yet sharing the experience with others is nicely captured with couples. Watch them. They enter an exhibition together, drift towards the panels of introductory prose. One of them moves along more quickly than the other towards a first picture. You perceive a vague loosening between them. They are no longer having a conversation or walking somewhere in tandem. Individual attentions take hold. Space expands around them. One is drawn to a portrait across the room. The other is still reading at the entrance. Every once in a while they hook up again in front of a seascape. Curiosity and focus work like independent currents of wafting air, catching their sails at odd angles. One is becalmed in the midst of a portrait, the other already tacking into the next room. Oh, here's that still life your companion was talking about yesterday … he should see this. Where is that man? They are together apart.

If you were to map the couple's movements, their visit might look something like one of those famous ballroom dances in a Jane Austen novel. The couples form, take hands, face each

other in the middle of the room. The music begins, they step back, pivot, wander in wide circles, join and separate. They form in their motions other links and affinities, testing them, letting them go, circle and return, the spaces of their mutual regard expanding and contracting. In Austen, social dances are mobile metaphors for relationships themselves, embodied and activated: the witty and complicated movements of people towards and around and through and past one another. It is love, intimate connection and attention, worked out as a social puzzle.

Yet the couple in the gallery differ from Darcy and Elizabeth, for instance, in Austen's *Pride and Prejudice*. There is parting and joining, but it is less choreographed, more spontaneous and accidental. What is more, they are not working out their relation to one another, but their relation, together, to other things. The dance that results differs accordingly, as the differing appeals of the things around them determine.

Since there is so much complicated movement, a preposition should help us out here. Movements *around, towards, before, after,* and *into* will certainly apply, among others ... but *with* is especially poignant. You are *with* your friend visiting a gallery. You spend time *with* the paintings. You go *with* the flow. *With*, though, is a rather coy preposition. It suggests connection and accompaniment. But there is also a kind of resistance built into it (derived from the Old English prefix, *wiþ-*), a movement *against.* You *with*draw money from your bank account. You *with*stand attacks. The word is anchored in roots as old as the language and wanders among ideas of towards, alongside, against, opposite to, and their like. At the heart of *with* lies a peculiar, divided energy where the movements towards and against are reciprocal, built into each other, mutually affirming.

With is quite at home in a gallery or museum, parsing out its energies, its gives and takes, among groups and couples, among paintings and viewers, indeed among the paintings themselves as viewers move between and around them. We can think of the complexities of *with* as actually causing the dance: to move *with* is to manage nothing but. The groups dance, the couples dance, the paintings dance. What is the great unchoreographed masquerade but a metaphor, folding and unfolding, for relationships themselves and the loves that hold them together?

The Hawthorn Bush

How often have you felt unequal to the gallery moment? There's you. There's the picture. What now? Nothing is happening. We're bound to feel this way at some point in even the most memorable of visits. The encounter is almost embarrassingly simple. The painting puts directly in front of us, as it were, the nakedness of the encounter itself. It may be partly that nakedness that keeps us moving. So many paintings to look at. Should I concentrate on this one or the one beside it? And then the one beside that one. So many pictures to look at. I mustn't take too long if I'm going to see everything. And I am looking to see everything. It may be my restlessness with things in the world that leaves me crashing up against the gallery moment, the moment of standing and looking. We live with staler moments of looking all the time. You take your dog for a walk. You've done it thousands of times. Everything is pretty much the same. That stop sign at the end of the road, can you make it mean something? Can you lavish it with attention and demand that it yield its long-hidden secrets? Can you refuse not to pass it by until it has flowered into a memorable encounter?

The narrator in Marcel Proust's *À la recherche du temps perdu* has such a moment. On a country walk, the young Marcel stops in front of a hawthorn bush. He looks hard for a moment, feels nothing in particular, turns away, then turns back again for one more effort.

> Then I turned back to the hawthorns and stood as before the great masterworks which one thinks one will see better when one has ceased for a moment to look at them; but however much I made a kind of tunnel with my hands to focus on the flowers,

> the feeling they first awoke in me remained obscure and vague, seeking to release itself and adhere to them. They provided no help, no illumination, and I found no satisfaction in any other flowers around.

The effort turns out well enough for the narrator. The point for us is that he had tried to make the most of an unpromising encounter. He felt a hunger in himself for things, for *some* thing. He wanted to make a connection, "float across," or meet it halfway, a marriage of attentions.

Proust next likens the moment with the hawthorn bush to an encounter with a painting, where we are inspired "with that rapture which we feel on seeing a work by our favorite painter ... or ... shown a painting of which we have hitherto seen no more than a pencilled sketch...." The narrator's evolving states of mind are rich and suggestive. He feels a sense of accident, serendipity, surprise, and in the object itself a sense of eluding promise and possibility. Answering in turn is his own appetite and expectation, his observation, his questioning and desire, and then his frustration, his sense of impending failure, then more desire, then more effort, and so on. On the next page Marcel is going to cycle through a similar gamut of emotions in response to a sudden encounter with his first love, Gilberte. She is the next "masterpiece," the next "hawthorn" on his walk. How we come upon and relate to objects in nature, loved ones, paintings in galleries, says a great deal about how we move through the world and what we are likely to get out of our encounters with it.

Proust's triumvirate here—encounters in nature, in art, in love—reveals his preoccupation. The artful encounter is most fully explored in the "death of Bergotte" scene later in the novel, which we will save for later. For now, he reminds us of what is at stake when we stand in front of a picture and look. Driven by a desire that there should be moments of genuine encounter in your life, you stand before the intriguing and mysterious other, and instead of treating it like an object, you seek a revelation of what it is, in itself, and of what you are, yourself, in relation to it. There you stand.

Little Parlor of the Fishes

Rooms of paintings are forms of macrocosmic display; they evince so many worlds spinning outwards around you in all directions. Like a single planet in their midst, you revolve to take them in. You might well be in a planetarium. But there is also in gallery and museum rooms that same relation turned inside out: the microcosmic display, minute glassy worlds that you gaze down and into from the outside. Polished vitrines of Eocene fossils, cabinets of roman coins. Such little cases of curios are more familiar to us, no doubt, as they resemble the little gatherings of keepsakes and snapshots we might have at home. I love them for two reasons: I can lean on them and rest, and I can take off my glasses and look at the objects in detail. You needn't feel daring in getting your nose right in there. To peer so closely at a painting is to risk being tackled by an attendant. Here there are no worries. These little things somehow look after themselves. There is, of course, the usual paradox of the display case, which both holds forth and withholds. It says "Look at these," and it says "That's far enough."

I love the sense in the museum display case, whatever it should hold, of looking into a small fish bowl, luminous and refracted. I think of Henry David Thoreau cutting a hole in the winter ice at Waldon Pond and looking down, as he says, "into the little parlour of the fishes." Standing over a display case, you are fishing for something in another element. You look down into it, wait for a nibble. Something glimmers, swimming and alive, in its luminous depths.

Jars in the biology department only extend the inference. Such a frisson I feel peering into these small bottles and

alembics, their quiet, tea-green oases, vessels of a magnified clarity, at once both heavy and fluid. Things being preserved in "solutions." Something still very much biological is protected from the ravages of the atmosphere. We ourselves, of course, move through a space that ages rather than preserves us. But here on these glass shelves is discretion and safekeeping, little heavens where creatures float peacefully in an enlarging, buoyant, and clarifying afterlife.

Every painting in a gallery, every dinosaur fossil, lies in its own invisible jar of formaldehyde. Discreet barometers control the moisture in the air, and window blinds protect the walls from direct sunlight. The museum itself is a jar of formaldehyde. Here, found specimens, still seemingly alive and changing, are preserved in their original form. They float and abide. They stare back at you, ghostly, expressionless, but intensely realized. One last revelation here. Shake your head gently: your mind too is a jar of formaldehyde.

Jeweller's-Eye

Drawers in a museum are a kind of "almost storage." They have the contrasting feel of either the scholar's cache in the research lab (all those pins flying their little identifying paper flags) or so many cisterns of overspill, a surplus of specimens. They say: "here are some more of what you have seen elsewhere, for further reference." Laid in the cotton batten of a small white jewellery box is, here, a little bird's beak, intricate and fragile as a feather, there, two fine examples of the mosquito subfamily Orthopodomyia. Priceless gems. Diamonds in the rough. You are the jeweller, and your thought about them is the jeweller's-eye magnifying glass that you raise, squinting. It is the very notion of the "curio." Your hands move irresistibly to the drawer handles. "Now what do they keep in here?" The sound of wood sliding on polished wood, whispered secrets. You slide the case out, feel its collection edge into view. It motions towards you.

I love the inference too, among those heavy compartments and dark oak cabinets along the walls, of private belongings. Sock drawers, intimate keepsakes. A set of cufflinks, a love letter, a last will and testament, the things others needn't see. They say: *this is personal.* We all have them. When I graduated with my BA from the University of Toronto, my parents bought for me a standing display cabinet, three tiers, with glass doors that squeak up on metal hinges. In the top cabinet are the things I like to keep safe: my father's railroad pocket watch with its chain and fob, my mother's nursing ring, a very fragile sand dollar from Jamaica, a cone from the almond tree in the front yard of Bonnard's house in Le Cannet, my maternity bracelet that has somehow made its way back to me, an antique *pince-nez*

Momento: On Standing in Front of Art

in a leather slip case, a small bird's nest with two dried, empty robin's eggs, one light blue, one white with speckles, the clay hand impressions that my son and daughter have made, a fish fossil in limestone 40 million years old, a small clay antique oil lamp, 400 A.D., small black and white photographs of parents in their reassuring diptych frames, a dried flower from my mother's funeral laid down in front of her picture. I keep them in no particular order, for their gathering here is all about whimsical juxtaposition, the fish fossil beside the pocket watch, the maternity bracelet near the fragile sand dollar, my children's clay hand impressions by the empty robin's eggs. I can move them about. Everything belongs here. There are no identifying name tags. Nothing needs to say what it is.

Empty Bowls

I love the idea of things in museums being examples of themselves, that they mean what they are. It is true of everything there, really, but I feel it especially strongly with empty bowls. Those rows of clay or bronze vessels under glass in the The Gallery of Greece, the Ancient Greece section of the Royal Ontario Museum. Small lights shine beautifully into them, as though to keep checking. You don't see too many people there. I remember walking through this gallery once, and noticing that I was not looking at anything, slightly distracted. I made a decision to find what I thought was the least interesting object and stare at it deliberately for as long as necessary to make something happen, like the boy Marcel at the hawthorn bush. Empty bowls are great teasers. They cry out. I was suddenly reminded of another piece in the ROM collection, a stooped figure in the Galleries of Africa: Egypt entitled "Mourning Woman," about six inches high, very simple somewhat Picasso-esque body shape with two long arms raised overhead: empty hands reaching, grieving hands, hands not filled with what is lost and longed for. I see the bowls this way.

The museum bowl was once functional, it held something. Now it is set behind glass. It says: I am a bowl. There are moments when I almost want to laugh at the audacity, their brazen confidence. Yet of course there is also an ordinary *thereness* to the bowl that is not exemplary. It is made of clay. It takes up an actual space in the cabinet. It is made of molecules that are like other molecules in the universe, like the ones that make up the cereal bowls in my kitchen cupboard. The molecules behind the glass, if they were capable of thought, would have no reason to feel that they were examples of themselves, or examples of

anything. It is their having been set behind glass that makes all the difference. There is a label beside them: thrilling. What bowls primarily hold once they are set behind glass is their own bowlness. They hold "I am a bowl," filled to brimming with what they say.

Now what about a painting? A painting is already a representation of what it depicts. Unlike most bowls, its function is to represent something. Plato would have said the same about the bowl, that it is already the representation of an abstract form of a bowl. But there is an additional remove in the painting, in that its function is achieved in *being* a representation. And yet, there is still an audacious thereness to it that is akin to the bowl's ordinary bowlness, a sense in which it says, as it hangs before you, "I am a picture." We're talking about two different forms of content. Just as the bowl was once filled with real objects, we can think of the picture as being filled with whatever scene or people it happens to represent. But now, as the hollow of the bowl is filled with nothing but its bowlness, so the painting, an illusion, may be filled with nothing, have nothing inside it. I think of Magritte's famous painting of a pipe entitled "This is not a pipe." I guess if one were to follow that logic to its end, it would make sense to put in front of the marvellous empty bowl from ancient Greece a little plate that reads "This is Not a Bowl."

The Waiting Room

Downstairs (usually) is the museum's storage. Purgatory. Limbo. The waiting room for paintings. Without magazines to flip through or muzak, they bide their time. Like the souls in Dante's *Divine Comedy,* these are works that are not, or *not yet,* counted among the blessed, the elect, the chosen few. They have not risen into the light. Consider: most galleries are really only tips of icebergs. At the Centre Georges Pompidou in Paris, for instance, visitors see only 5% of the gallery's total collection at any one time. There are many paintings that have never been put on show, some perhaps never seen at all. The majority of visual art in the world must be like those sports professionals who spend most of their careers slogging away on farm teams, who go up and down regularly and are called up when they are needed. As they say in baseball, they hope to "make it to the show."

In storage, paintings and museum artefacts are not normally inaccessible, just removed from display. The idea of storage reminds you of one yawning truth: the purpose of art is to be seen. Not to be seen is scarcely to exist at all. Does a falling tree in the forest make a sound if there is no one there to hear it? Are these paintings what they are when no one is looking at them? There in the dark, wrapped in heavy cloths or nailed into wooden crates, rest minor 18th century Italian portrait painters and also-ran Dutch landscape artists. Time has stopped because the aging light does not reach them: a modern Lascaux.

New technologies have introduced mobile storage solutions for museums. Wire partitions fold together, like accordions. They breathe in and out. Curators sort through them, a modern Rolodex. Paintings are hung there as though offered for view,

but offered to no one. The space for looking at them has been collapsed or erased. A gallery of unlooking. The works face one another directly, both artefact and audience. God forbid that two shy portraits, disasters at small talk, should be pressed against one another for all eternity.

The basement caverns, the secret inner crypts. Is this where the paintings or bowls go in order not to do their work? Or is this where the nature of their work merely changes? Think of the ancient Egyptian tombs: objects were buried with the deceased pharaoh in order to be useful to him in the afterlife. Life-stores of every sort, linens, perfumes, jewellery, models of ships and houses. No one would see them again, but in the minds of those who thought of them, they went on in those unlit spaces sustaining what was dead there yet still strangely alive. When Tutankhamun's furnishings went into the dark, their abeyance was the space of a possible resurrected life—our own modern world—that lay still ahead of them, one that came to light at last when the tomb doors were opened again. They travelled a long way indeed. At the same time, they were only objects, objects that, in the end, hadn't gone anywhere at all, objects that could be resurrected in a secular and material sense for the very reason that they hadn't gone anywhere at all.

What is dead here in gallery storage? What lives? What travels and transformations do these artefacts participate in? One answer perhaps: the idea of the afterlife itself. I've often wondered about this term "afterlife," a slippery one to be sure. For those who want to know if you believe in it, the word refers to some idea of life after death. A life after, of course, is an "afterlife." But the word, without too much squinting, could also easily denote whatever it is that comes "after life." In which case, yes, of course one believes in it. I believe in the afterlife, I'm just not likely to be around to think about it.

I would like to think that my "after-life" will be like the "afterlife" of museum storage. Paintings are "laid aside" in gallery basements, an image of what we ourselves as makers may look forward to. For the most part the artists of these works are long dead and gone. In a very real sense, their bodies and lives have been *laid aside*. Yet here are buried their artefacts,

their bowls, fossils, and coins, their landscape paintings and portraits that, like the pharaoh, they will need in order to cross over into a further cultural vitality still ahead of them. I feel it myself. Don't we all? I do believe, or would like to, that what I make of myself—however minor those things be—will have some purpose or function "after life," and that I will somehow be *in them*. As in the pyramids of ancient Egypt, they will be laid aside in a kind of *meanwhile*, a purgatory if you like, where, without going anywhere at all, they will wait to come to light again. And should that time come, they will have left behind the small, dried body of the pharaoh and moved on to "the show."

It is perhaps only what the museum itself is. Perhaps only what our lives are. Like these works travelling in and out of storage, we live in and with an abeyance, a withholding, a not-yet, that is always about to rise into its promise. We hope the things we are and do will someday take their place among other good works in a community of mutual regard. If we are the ache of abeyance, we are its fulfilment as well. I said above that works in storage are not yet "risen into the light." Might it be what a painting thinks heaven is, the place where all you are is at last revealed, where you meet, face to face, the one who truly sees you? But it would be truer to say that they are not yet risen into the *light of day*. For that, finally, is the world that paintings *look up to*: not the clearings of an only imagined heaven, but these simple rooms we ourselves have designed, built, and wander among. It is already where we are, the heaven that paintings long to reach. For these clay vessels, these wooden boards smeared with paint, we are the resurrection and the life.

The Watch-watcher God

They are everywhere: shy, introverted, otherworldly. The gallery attendants. They do not speak to us. They drift near to one another, whisper a word. We scarcely notice them as they come and go, rest at thresholds, watch the sky through windows. Are they like the watch-maker god, the one who sees a world into being, opens its doors at dawn, and then steps back to observe what happens? They oversee the room but pretend not to be in it, not as we are in any case. They are not lookers-upon, but watchers-over. Yet attendants will stand back and look at a room in the same way that you stand back and look at a painting, engaged or distracted, noticing this or that move or gesture, growing a little weary of trying to see well as the afternoon lengthens, but like you certain that the prosperity of what they see is partly dependent on their own careful attention.

I sometimes imagine that they are there for another reason. Think of what happens. We wander through the rooms and get lost in the labyrinth. The entrance recedes. The rooms gather and spread and the afternoon falls away. Where are we? With their pacing about, their standing by, their sitting and staring, their infinite patience, the attendants are reminders. Are they waiting or not waiting? It is hard to tell. If they *were* waiting, they would be waiting for nothing. They would be the presence of waiting itself. They finger their watches and look at them, but 1:15 and 2:45 pm are the same to them; you can see it in their eyes. They are what happens to time when time enters the labyrinth. It slows and abides. You look at them and you think, they are not waiting.

In the end they are not watch-maker gods, the ones who turn away from the living scrimmage. A surveillance camera

hung in the upper corner of a gallery room makes a better watchmaker god. It sees all, but does nothing. On the other hand, when there are shenanigans, the attendants will intervene. They are more like guardian angels. Yours or the paintings? Their job is to hover nearby, almost invisible. They are agile in crisis. They mind the thresholds and leave you to yourself. "Wisdom's secret," said Northrop Frye, "is detachment, not withdrawal."

Take a Load Off

Energy, stamina, exhaustion: how quickly you become aware of them, spending a day at the museum. The physical demands of looking at art and artefacts are worth a word or two. Yeats has a line in his poem "Adam's Curse" about how the poet's work of articulating sweets sounds together is to work harder than your typical manual labourer:

> Better go down upon your marrow-bones
> And scrub a kitchen pavement, or break stones
> Like an old pauper, in all kinds of weather....

Beautiful as the lines are, I sometimes wince at them. I expect they could only be written by someone who hasn't had to break many stones in bad weather. A couple of hours of that and Yeats would almost certainly have begged for his quill back. I also think that he intended a metaphoric comparison, rather than a literal one, making a shyer point, that there is a certain form of exhaustion we can feel when mental attention and physical effort become involved. I've known certain kinds of exhaustion in my life—say, working as a bicycle courier in downtown Toronto, or marking three hundred exams in two days: that is to say, total, without being punishing—but there is a unique tiredness I can feel at the end of a day in a museum. All that standing in one place and looking, it can be hard on your back, the way your body carries your attention.

It would be fun to do an experiment. Map a visitor's path through a museum, the stop-and-start, the keeping-still, the going back and around. Then transfer his route to an open field somewhere, have someone perform the visit again, the duration

of every pause, the meandering movements. How strange it would be to watch him, that man in the middle of the field. What would he look like? What would you imagine if you saw him there? A madman? A lost soul? But now I wonder: would the man grow weary more quickly, less quickly, or at the same rate, than he would doing the same thing in a museum? Would it be more tiring going through these motions in front of *nothing at all*, or less tiring? Isn't that what we are doing most of the time anyway, going through motions? Is this perhaps what exhausts us so? Or does the exhaustion come from trying not to … go through the motions?

You are exhausted. Something has been poured from you. Is it worth noting, in our case at least, that the word is cognate with "exhauriate" from the Latin that means *to draw out*. Exhaustion is energy drawn from you, not energy expelled. Not wind pushing a sail, but a flow of electricity when you plug in an appliance, negative charges drawn towards positive ones.

This is why galleries provide the occasional bench or seat for periodic breaks, metaphoric or otherwise. There is also something suggestive about *places to sit*. There they wait, in the middle of the room, both a part of, and apart from, the works you want to look at. It is mostly luck if a particular bench gets you close enough to your favourite work. In the end, there are so few places to sit. It is perhaps why seats in a gallery seem so much like *an example of resting*. They represent the patience that the paintings call out for, even a metaphor of the paintings themselves. A place of rest. They offer for the body what the paintings offer to the mind: a space apart from which to enjoy views. And of course, as a place to rest, a painting is always just the right distance from itself. The place *of* rest and the place *to* rest become the same place. How exhausting.

Something Happens

Not bringing the Impressionists into Focus

William Blair Bruce, *Giverny*, 1887.

Have you ever tried squinting at impressionist paintings? Try it next time. Something of the reality of the landscape suddenly leaps out at you. In squinting, the viewer adds an actualizing distortion. It seems strange that a painted scene should come clear when you blur it, but it can. Squint that Monet or Pissarro into a blur, and you find yourself thrown headlong into the elusive airs of the original moment. William Blair Bruce's paintings at the Art Gallery of Hamilton work well this way: squint at his "Giverny" and something happens to the degrees of light and shade, the reflecting water; you get the strong sensation of a total space, things in front of and behind other things.

It was some time after I'd got into this habit of squinting at just about everything that I came across this passage in a work on Caillebotte. Joris-Karl Huysmans in *L'Art Moderne* (1883) writes of an exhibition of the artist's work in 1880: "In the end, Monsieur Caillebotte has rejected the impressionistic approach regarding brushwork, which requires the viewer to squint up his eyes to get the people and object to come clear...." I would venture in reply that this was exactly the point, a *trompe l'oeil* effect where the perceived world falls together according to how you observe it. That's why it's called Impressionism.

You can get some interesting results in other rooms—the early Dutch landscape painters for instance—but the trick doesn't work for all, or even very many paintings. You can squint at a Canaletto as long as you like, but all you get is a sense of what the actual scene Canaletto was looking at would have looked like if he were squinting at it. Whereas with the impressionists, the scene *comes clear* in its eidetic thereness when you squint: not more blurry, but less. What you are glimpsing is also more than just the ordinariness you would have felt had you merely been there with Bruce at the time. For you still see the object as a painting, an expression of itself, and that adds something again, a sudden *offering* of its two realities at once, an actual and an imagined. Nothing like it!

Does it work with reproductions? Walter Benjamin wrote about the difficulty in his essay "The Work of Art in the Age of Mechanical Reproduction." One loses "the aura," he says. I'm not sure if I'm talking about the same thing. I certainly take Benjamin's point about the difference of reproductions—it's why visiting an art gallery is so little like flipping through an art book—but any painting would have its private and treasurable aura as Benjamin defines it. I'm talking about a different kind of trick, and the sense of another kind of aura that comes clear in certain cases.

Let's go back to the impressionists. Painting for them is a translation of a scene into the colour codes for actual 3D vision, or something like it, which can be distorting. They sought an impression of how things occur to the actual subject-eye. Our squinting is like putting on the 3D glasses to reverse the process

and glimpse the presence of the original again. And yet it isn't really three dimensions that come clear, or at least not only that. And what you see when you stop squinting is not what you see when you remove the glasses. Let your eyes focus again on the painting, and you see the put lines, the strokes, the blotches of paint standing collectively together, unpretendingly, like a kind of wizard who has laid down his wand. You see the paints there, arranged and set about on the canvas as they are, and what you feel is the frisson of watching a magic trick, with the accompanying pleasure of moving back and forth at will between knowing and not knowing how it is accomplished. Until what you see in both states of mind is the same thing, and you don't need to squint at all.

Tomb Supplies

When we paused at the coat check, we thought about this problem of what you can and cannot take with you as you prepare to enter strange places. We're not done thinking about supplies for a journey. Look for your museum's collection of Egyptian antiquities and see whether it doesn't include examples of tomb supplies, i.e. provisions for the afterlife that were buried with the pharaohs in their pyramid tombs. Their familiar world reproduced in miniature: a wooden diorama of slaves working in a granary, model boats for transporting the deceased to an imagined destination. They answer to every need. Weaponry, dress, regalia, luxuries. I picture mourners laying these objects in the tomb and how they would visualize their value. Perhaps for that very reason I also love the kind of ordinary, unpretending thereness of the objects themselves, especially as we dig them up millennia later. They lie about the preserved mummy like a magician's paraphernalia found in his storage closet.

This equipment tells us much about the metaphoric imaginations of the Egyptians and how it differs from our own. I think of the Egyptians as very sophisticated metaphorical thinkers. These boats intended for a voyage into the afterlife, what sort of imagination do you need to busy yourself so with such offerings. We like to think of our modern selves as sophisticated metaphoric thinkers, with a certain savvy about mimesis. We would never be dumb enough to think that a model boat buried in a tomb is going to carry the deceased anywhere at all. Our imaginations are all about displacement. We experience a fundamental alienation in metaphoric thinking, where every likeness is seen as only that, a likeness. It is not the thing itself.

Egyptian Model Granary, Royal Ontario Museum.

Think of the Egyptians going about their business. The Pharoah hears thunder in the distance and he says, "the God Baal is angry." Is he being primitive or sophisticated? Someone may come along and say, "Oh yes, and incidentally Mr Pharoah, when you said that the thunder was the god Baal being angry, you were actually thinking metaphorically, whether you knew it or not." What you would miss in your condescension is the sense of existential immediacy, a habit of thinking that one thing is another without troubling over its metaphoric status. From our perspective there is certainly a kind of savvy that goes with being able to tell the difference between a symbol and the things symbols point to. We can twist ourselves into some impressive knots (nots! naughts!), playing around self-consciously with our signifiers. We think that an ancient Egyptian's too eager identification of symbol with thing shows a naivety, but it may be that theirs is the kind of identification one makes on *the other side* of mimesis, something which the boats themselves journey to make real *on the other side* of the actual. It is a going "whole hog" with the work of conscious thought, not a simultaneous application, and then disavowal, of its properties. Wallace Stevens wrote that

"final belief must be in a fiction which you know to be a fiction, there being nothing else. The exquisite truth is that you know it is a fiction and believe in it willingly."

There is plenty of evidence in Egyptian art and hieroglyphic literature that Egyptians were capable of thinking about symbols and symbolic representation. The great stone panels told stories, tales of both historical and mythological events, sometimes side by side as though to suggest that they saw little difference between them. The fact that they knew what a symbol *was*—how it would be put for something that was actual—shows how their imaginations were not innocent or naive in the sense we usually mean.

An ancient Egyptian looked at these little wooden boat models and could think of them, if he wished, as *actually* serving to transport the ruler to faraway places. This is not a scene in which the voyage across is *depicted* as happening. Rather, the means for the voyage itself are supplied. It is not what the boat *means*, it is what the boat *does*. There are interesting transitional examples that help to evoke the Egyptian mindset. Some of the boats buried in the pyramids are life size (as for instance the great boat pits in the pyramid of Khufu in Giza, Egpyt). That is, they are large enough to carry the Pharoah where he needed to go. Actual slaves, how awful, would be killed to work the oars. Think of how almost not metaphoric at all, that is to say how radically metaphoric, these arrangements were. Again, they are used to transport the dead, not to *mean* that the dead are transported. Of course, with the appearance of *model* boats, we begin to move slowly in the direction of a self-conscious mimesis, but the move to smaller models was apparently easy, for the Egyptians were already accustomed to thinking of the journey in metaphoric terms. If you think of the Pharoah as climbing into a boat that he can easily fit in and then sailing off into the actual sky, you are already thinking imaginatively. You would have no trouble shrinking the boat down. In fact, it is part of your imaginative agility that you would do so. Saves on lumber.

Egyptian mummies were buried with actual food. It makes the same point. A model boat lies beside real food: one is for actual eating, one is for actual transportation. Real food

for metaphoric consumption. One eats the metaphor. Let the other metaphoric shoe fall and you can see how the metaphors themselves are a kind of food. One is nourished by them; one takes them to oneself. The food can, without loss, be thought of as metaphorical because metaphor is already thought of as a kind of food.

The other thing about model boats as metaphors for actual passages is that metaphors themselves are *transitional* figures. They get you from one place to another. Metaphors are, metaphorically, boats of a sort. That's where the word comes from. *Meta-pherein* ... to carry across. The model boats you imagine as real boats, then, are metaphors of metaphor. The upshot? It is metaphor itself that is radically identified with. Metaphors are planted in tombs. They carry you places, do actual work, as the model boats themselves were thought to do, metaphorically.

If you weren't a Pharoah, you could still be buried with a more modest collection of supplies. If you were among the affluent, you might be provided with the model of a clay house. I find examples of these heartbreakingly endearing. Nothing too fancy, a bungalow with a tiny stairs rising to a small loft above, perhaps with a charming diminutive window looking out onto ... onto what? There is a fine example in the Royal Ontario Museum. These "homes" in which the souls of the dead were thought to find their dwelling are called "Soul Houses." I like the double entendre: a house that is *made of* the soul and the house that *houses* the soul. The soul in a house. The soul as a house. Therefore, soul dwelling inside itself.

Our attitudes changed long ago. With the ancient Greeks you begin the slow journey towards a more self-conscious *mimesis*, where you are aware of yourself as displaced from the identifications that you like to make. Aristotle's *poiesis*. Plato's suspicion of artists and the illusions they trade in. At the Fitzwilliam Museum in Cambridge, Britain, there is a wonderful oil flask, terracotta lekythos (ca. 450 B.C.), entitled "Charon, Hermes, and youth." On the side of the flask is the illustration of a young man being escorted by Hermes to Charon's boat, in which Charon waits to transport him across the River Styx to Hades. The plaque reads:

> Hermes, identifiable by his winged boots and herald's staff, beckons a young man, the deceased, toward Charon's boat. Charon wears the clothing typical of a Greek workman—the exomis, a tunic that is fastened on one shoulder and leaves both arms free and bare, and a cap with a narrow brim.

There is a fascinating difference between a flask like this, with its depiction of a familiar mythical scene, and the Egyptian sense of a more "literal," which is to say more figurative, embodiment of the desired and imagined moment. The Greeks are already growing accustomed to thinking of these scenes in more consciously representational ways: clearly this is only a picture of Hermes doing the work that Hermes is thought to do. The rest is left to our imagination.

We sometimes think of metaphors themselves as kinds of tombs, where "real" things or ideas go to die. But consider all these objects spread around the dead. Provisions for a journey. I think of the modern souvenir—in galleries and elsewhere—as the same idea, only in reverse. We go somewhere and we buy a thing so that the experience we have had may become real once again, recalling a presence, restoring a lost world. Often enough it is just knickknacks. We want it to do the kind of work the model boat did for the Egyptians, but in the end find, given our doubtful imaginations, that they only meekly summon what was probably only imagined in the first place, the longed-for original and the world it spoke of. It was the world we left behind too eagerly because we were in a hurry to get to the souvenir shop, with its souvenirs which lie about there, how ironically now, like dead objects in a tomb.

If you have eyes to see with

One brief observation about how the Egyptian mummies were embalmed. Artificial eyes were placed in their sockets. How brilliant of them! Artificial eyes for the dead to see artificially. It is an altogether different idea of seeing, or of how to see, or of what one needs to be able to see. We think such eyes would make them blind, more blind even than they already are, being dead. Fake eyes. Eyes that don't work.

But perhaps not. Perhaps when something that is not alive is given *artificial* eyes, it begins to see. It now has the sort of eyes, unreal ones, that something not alive would need to see properly. Or turn the case inside out. Perhaps we are the dead ones, indifferent, incapable of vision. Perhaps we have the *real* artificial eyes, that is, eyes that only *look like* they are seeing. The dead with *their* artificial eyes, the wide-open unseeing eyes of artifice, may look as *though* they see a good deal more than we do. There may be visions in those eyes, visions *that we can see* are there. Visions that only the dead are capable of. Or look at it this way. Given what is there for them to see, the dead are given artificial eyes that they might see it.

A Bridge is a Lie

Incidentally, if you're going to cluck your tongue at the Egyptians and their "myths" of an afterlife, we need to step back. Scientists and other materialists like to use words like "fiction" and especially "myth" as meaning primarily what we know ain't so. It's a myth that the world is four thousand years old, and so on. Our enlightened Enlightenment thinking seems to have caused that word to split off from itself—ancient myths are myths!—so that we can now scarcely differentiate two ideas: one, that Egyptians, like us, told stories with art in order to make their lives intelligible, and the other, that they, rather quaintly, made stuff up that is just wrong.

 I teach a first-year English course called *The Written World*, in which we explore works of the human imagination and think about their relation to what we call the actual world. "You need to see the truth," say engineers and physicists, "and live in the real world. Your stories are fine, but let's not mistake what you do with what we do, where the real work is accomplished." I start the course by talking about these popular dispositions, then try to throw a stick in the works. I say, "A bridge is a lie." Then I wait for reactions. "Bridges...," I say, if they don't take the bait right away, "Bridges are not about the real world. They make stuff up about where the real world actually is. The actual world..."—I start drawing on the chalkboard—"... goes like this, down and down into a valley, then, oh my God, across this dangerous river, then back up, over rocks and crags, to the other side. The bridge would have you believe that the way across that dangerous space actually goes like this...." I draw an arc over the valley. What a bold-faced lie! It doesn't even try to hide the fact that it is

deviating from how things really are! It makes up an entirely imaginary route through and across a world that isn't there.

And what's more, the people who approach the bridge in their cars don't screech to a stop at its threshold, run to the edge and point—like good scientists— into the gulf, and cry "This bridge is a myth, it isn't about the real world!" No, in fact, so confident are they of the kind of world the bridge "points out" to them that they quite happily "go with it." The bridge myth says something meaningful about how people like to move in the world, even though—plain as day—the world itself goes another way entirely. Their driving onto the bridge is an act of faith, a "going-with" the implications of the kind of world the bridge has imagined, and recommended, as meaningful. And just think, if they didn't "go with it" in such a leap of faith, the bridge itself in time would fall away as useless, quaint, some ancient civilization's charming idea of how the world *went* way back when.

You can see where we're going with this. Human beings make things up, and they make them up because they believe they could use them to make life better. They make up iPhones and laptops and toasters and bridges and classrooms and paintings and art galleries. Our going with those worlds, our using them, our keeping them *at hand*, actualizes the myths that they recommend to us. And looking at them, the iPhones and the paintings, we can learn something about what that species is, what it needs and values, just by considering what it makes.

An Egyptian model of a boat to the afterlife, or a Claude Monet painting of Charing Cross Bridge in London, are in every meaningful sense *actual* bridges into recommended worlds. They even deviate, like the real Charing Cross Bridge, from the actual world and how it goes. Like that material bridge, Monet's painting and the Egyptian boat concretize an imagined world that is showing us a way into, or through, or across the place we find ourselves in; it is as expressive of human desire and human reality as any highway. Your *going with it*—standing there in front of the painting the way you do—is as profoundly actualizing of the kind of world that makes sense to you, with its way of seeing and its way of being, than any bridge engineer or quantum physicist could wish.

On Being Watched Back

In The National Portrait Gallery, London. What if, like those paintings hung on the walls of the Hogwarts School of Wizardry in the Harry Potter series, the figures depicted on each canvas were able to look back at us. Wall on wall of figures staring down, somehow aware of who was passing before them. Their painted eyes are like the glass eyes that the Egyptian dead are buried with. Painted eyes are what painted figures need in order to see what is strangest about the living world. Often enough we come and go through these rooms with the dazed and otherworldly look that we see in the figures themselves. They hang there and pass the time. The gallery opens each morning, people come and go. Time passes for the portraits in the same way that space passes for us. We see many portraits as we move through the rooms. They see many of us as they endure through time. They watch us come and go over centuries. Some of them are taking the trouble, this day above all days, to pay attention, see us for what we are, while others among them have succumbed, staring blankly, no longer seeing much of anything. The frozen expressions, asleep in their own wakefulness. Our conscious lives may be like portraits hung too long on a wall.

As for paintings that can see us as well as we see them, there's the story about the fellow who wouldn't eat cow's tongue because he didn't like the idea of something tasting him back.

Working with a Painted Palette

London's National Gallery. I've been sitting for a while with Élisabeth Louise Vigée le Brun's wonderful "Self Portrait in a Straw Hat." Purple dress with a generous white trim around the cleavage closed with a simple ribbon. Full narrow lips, cheeks flushed with youth, eyes tending to languid. Her straw hat, like a sine wave, unfolds around her head, covered in red, blue, and white flowers, and capped with a feather that looks more like the tail of an ungroomed bichon sweeping off to the right, in shades of grey that match her shoulder length hair almost perfectly.

The painting is a self-portrait, but you don't want to think of Norman Rockwell's Triple Self-portrait, with its three perspectives: 1) a painting of Rockwell himself as the artist doing the painting, looking off to the side into 2) a painted-mirror reflection of himself, while he paints 3) a painting of himself looking straight back at us.

Le Brun is being less coy, or perhaps more. She does not paint herself painting. Instead, she is merely posing with brushes and palette, so that what would have been the moment of her painting is different from the moment (prior to it, or after?) of her seeming to pose for it. It is like that unsettling moment in spooky films when, looking into a mirror, the protagonist sees her reflection doing something different than what she is doing in front of it.

The head, the flowers, the cleavage draw plenty of attention. Le Brun is drawing our eyes away from another interest in the painting: her palette and her brushes. Wet daubs of paint. In the first row: a white, three yellows tending increasingly towards brown, then three reds going from a pinkish cherry to ochre or rust. In the second row, more towards the centre of the palette:

Élisabeth Louise Vigée Le Brun, *Self Portrait with a Straw Hat*, 1782.

a blue and a pink. The blue seems to have been used ... it shows evidence of a brush having passed lightly over it towards the edge of the palette. It has been dipped into. The front-row blotches of paint are pristine, fresh-squiggled onto the board. The palette as a whole is clean, except for these blodges of colour in two neat rows. The painter has scarcely yet begun to paint. There however, to bely the inference, is the painting itself with the palette and its globs of colour, quite finished! The artist

"posing" for her self-portrait with her painted brushes and her painted paints should not be confused with the actual painting artist who must have worked with real brushes and real paints, not the ones here that we see painted. But it is an interesting trick nonetheless. Think of it. The little splotches of paint on the canvas are "little splotches of paint on her palette." Or is it the other way around? It is a thing becoming representational in just being what it is. What else is that like? It is more than writing a poem about poetry, or even (though this may be closer) using the word "word" in a poem.

The paints that we see on the palette are the same colours as those used in the flowers, no doubt drawn from a similar (though surely messier...) actual palette. It is as though the painted palette, laid out there in two simple rows, represents the range of tones for the painting she would make, that is, the colour "palette" that she and the whole of her painting already embody. The little touches of white on each daub suggest a moisture capable of reflecting light. The paints are wet *and* dry! The painting becomes its own palette, in which its colours are in a sense made available to itself, to make of them what it will, as it has so clearly already done. The mere possibility of a painting becomes indistinguishable from its finished accomplishment. The painting offers to itself the colours that it needs to be what it already is. I think of the definition of faith in Hebrews 11: "the substance of things hoped for." It was the genius of Le Brun's own faith in her art that she should give us both at once, each freely granted in the other. The finished painting manifest in the act of painting. And the other way around.

Face and Field

Portraits are landscapes of a sort, and vice versa. Portraits depict an external world, an environment where someone lives, moves about, and tries to make himself at home. And landscapes are portraits: outlooks on a human view, behind which lies, latent and unrepresented, the "mind" that brings it all to life. Even the least interesting landscapes gain a further edge when you remember that you are not looking into an exterior world, but an interior one.

Lawren Harris, *North Shore, Lake Superior*, 1926.

You can try on this both/and—rather than either/or—metaphoric thinking almost anywhere. Certain paintings will surprise you with it. I remember staring at Lawren Harris' "North Shore, Lake Superior" at the National Gallery in Ottawa and found myself, it appeared, suddenly looking at the full-length portrait of a man, imperious and singular, gazing distantly into the northern light. He made me think of Rodin's sculpture of Balzac with its "I wrap myself around me" sense of human dignity. And then of Caspar David Friedrich's "Wanderer Over the Sea of Mists" (cf. 43), its expression of an essential solitude in infinite space. Figures everywhere. And then, like that drawing of the duck/rabbit illusion, it snapped back to being a tree in the midst of our monumental north, the great spirit looking out from it—who saw it for what it was—no longer there.

Auguste Rodin, *Honoré de Balzac*, 1897.

It's All In Your Head

I Like What I Like

"Art is what I make of it." It's hard to disagree. Art isn't much of anything until someone looks at it, and what that person sees there is what, for her, the work is. What she sees is subjective and relative, personal; there are no right and wrong answers. It is all very reassuring. And very true as well. But, if you think about it, there is something about the "anything goes" approach to art that can be rather deflating. If a painting can be made to mean anything I want it to mean, how can it mean anything at all? Skeptics cluck their tongues. What a useless exercise. Are there no limits? The problem is that we find ourselves caught somewhere between two unsatisfactory extremes. At one extreme, I am the authority here, and the work is subject to any of my whims. At the other, the work (or even worse, the artist...) is the real authority, and I am the outsider grasping at straws. The painting and the viewer are shouting the same thing: "if you don't know what I know, then too bad for you!"

I talk about this issue when I teach my first-year introductory course in poetry, in which all the same challenges and caveats come to bear. Sooner or later, you feel a certain attitude in the air: all poems are subjective and so the poem can mean whatever I say it means. You can feel the wind drop from our sails: if anything goes, then nothing goes. Then I offer an analogy. Pretend that there has been a crime. Two detectives have been called to the scene. They walk into the room. The scene of the crime, if you will, is the poem or painting. The detectives are the viewers standing before it. They look around the room. They see … what? A bookshelf pulled down on its side, a laptop beside it on the floor, a box of playing cards spilled into a waste paper

basket, a glass on the floor with gin poured out on the carpet, and a desk with nothing on it but three drinking straws and a signed photograph of Mick Jagger.

What do the detectives do? To start with, they make an important and very simple assumption: *the room is meaningful*. Something is true of the room, something can be said about it. Something has "happened" here that they don't yet understand, but they can be pretty sure that what they see in front of them are potential clues that will repay some reflection and lead them closer to the "event". Everything they see may be considered a clue.

So, let's say Detective 1 is a bit of a relativist and believes that the room can mean anything he wants it to mean. He says, "Ah, I see! Look at all these books. The person who was in this room obviously worked for a publisher. And see the laptop on the floor beside it? Well, he was presumably frustrated with how few book sales there had been and in a fit of anger had pulled the bookshelf down on the lamp, knocking over a deck of playing cards while he was at it." Detective 2 replies: "That doesn't seem very convincing." "What do you mean?" replies Detective 1. "Can you prove me wrong? Anyway, it's just my opinion." "No," says Detective 2, "I can't prove you're wrong. What you say may fit some of the evidence here and might be one possible solution to the mystery, but it seems rather hasty and whimsical. As for its being just your opinion, what sort of detective are you anyway? Remember, it was something very definite that happened here. Something was the case. Even if we don't understand right away what it is, we shouldn't just go grasping at straws." Detective 1 is offended. "Well, do you have a better solution?" "Maybe not," his companion replies, "but let's start over again. We may not be able to say exactly what happened here—indeed those who were here might not be able to say—but there are things that we can say based on the evidence we've found. Let's look for *those*.

"Whatever happened here, it was part of a scene that involved either a struggle or an accident, don't you agree? Bookshelves don't typically lie on their sides in the middle of rooms. Those three straws might be related to the glass of gin, for they are both related to drinking; we can't be sure, but let's

keep it in mind. The fact that there is both a laptop and a glass on the floor may suggest that they were both knocked over. Possibly from the desk? And yet they were knocked in opposite directions, one to the left of the desk, the other to the right, so if they were both knocked over, it would have to have been in two different motions. And look at the deck of playing cards: some are in the wastebasket and some are around it. That might suggest either that they were tossed from a distance and partly missed the basket, or were accidentally knocked from the desk, like the others, and only by chance partly hit the wastebasket. What do you think?"

Detective 1 scratches his head. "Well, you're not saying very much. I was able to speculate on where he worked and everything." Detective 2 raises an eyebrow. "Our job isn't to say everything about what happened here. Our job is to try to find out what we can say with confidence, however minor, or abstract, or insignificant it might seem. All we can do is look at the whole of the room and see how all its parts relate to one another, the glass to the straws, the books to the laptop, the playing cards to the waste basket, the position of all these in relation to one another, which ones seem to share functions or contexts, which ones don't. What seems out of place. What seems missing. And so on. That's what we start with."

I made up this scene off the top of my head, having no idea if it would hold together as meaningful or not. Notice that the more random or mysterious the parts seem in relation to one another, the more we are likely to feel that what went on here can't be grasped. Not enough clues that fit together. Notice that the detectives don't decide that the room is just far too mysterious, even "difficult" as they might say, for them to trouble over. It would be odd for them to feel intimidated by the room and walk away, or conclude that the room was elitist or highbrow, too aloof in its meanings. Indeed, as detectives, they are likely to feel rather excited about the possibility of reflecting on the clues there. Like Detective Columbo, we would expect their eyes to light up as they hum and haw around the room, ask funny questions about what they see there, test possible patterns and relationships. They would be in their element.

The detectives were happy to find themselves somewhere in a middle distance between deciding, on the one hand, that anything they said was fine because it was all just them anyway, and feeling frustrated, on the other, that they could never know "the whole truth" about what they saw. They would of course be pleased with what seemed like a fuller picture, so to speak, but that wasn't necessary. They took any little thing they could find, and saved it for further processing down the road, in relation to other scenes they might come across and other evidence. Always connect!

Oh, and yes, the butler did it.

The Seer and the Viewer

We speak of the "narrator" in prose fiction, of the "speaker" in a poem, and we distinguish their functions from that of the writers themselves. But we speak less often of the "viewer" in a work of art. The "viewer" tends to be anyone who happens to be looking at the painting at the time. For a surrogate narrator, one would need some equivalent of the "seer" in a picture. The seer would be *in* the picture, the one who represents inside it the very agent of seeing what there is to see. Conventionally representational pictures—that is to say, pre-abstract art—seem to inspire the autobiographical fallacy. We look at a painting and we talk about where Monet would have been when he painted it, where he lived, what he would have seen there while he was painting. We show photographs of the actual spot where the painter might have stood. We less often distinguish the actual painter from the painted seer, the *projected* Monet, in the painted world.

There is *us*, we viewers of the picture. In a sense, we come closer to the seer projected in the painting than any idea of the actual artist observing the real scene. For what we view is the perspective of the seer, the seer that the painter creates. Monet projects *us*, by putting *what we will be able to see* down on the canvas and making it the primary condition of the world he has created. To look at the painting is to be the one inside the picture who is looking at the painted scene. Like the narrator of a novel, we go over the experience as he or she would have us go over it. We reproduce its mood, its way of seeing, its distractions and attentions, its love for one thing or another.

So we are inside and outside the picture at once. We become in the actual world examples of the person looking at the imagined

world from inside it. We objectify the painting's own inward, in-sightful perspective. Indeed, the painting does it so well, its conjuring of a particular way of seeing is so powerful, that a living person appears suddenly in front of it, you! seemingly out of nowhere, looking.

The Reflection of Moonlight

I am most pleased with a visit to a gallery if, after I've left, I can still feel the impression, an almost painterly presence in memory, of some minute detail: an outline of cloud in a Constable landscape, a thrilling glob of rusty red, several millimetres thick, knifed over an underlying grey in a Nicolas de Staël abstract seascape. In fact, I often take it as my main purpose to find the one small thing I will remember seeing and am reluctant to leave until I have done so. More often than not, the diminutive seedling is only *part* of something, not the whole. I feel as though I've found something secret, disguised in being right before my eyes, but neglected, ignored until now. I think of there being in the gallery—with so many paintings put out in public for so many people to look at—this one thing that is *for me*, alone, because today I will imagine myself, for what it's worth, as the only person who has noticed it.

I love the idea too that the "one special thing" will be something different for others, perhaps even something else in this very painting. I wonder: what would it be like if all the little parts that viewers have found to admire for themselves could light up at the same time? When I see the reflection of moonlight on lake water—one long, bright, sparkling road that makes its way directly to me—I think of how another similar line would also lead directly to others along the shore, and that if we could see the water as it would look to a god, an otherworldly eye that could gaze all at once from every direction, the entire gallery, I mean lake, would be on fire.

Being Beside Yourself

Medieval artists had a particular way of looking at the arc of a single human life. Our lives unfold in relentless sequence, we imagine, and so are best represented in art forms that favour time over space, such as music and narrative prose. The spatial forms of painting, sculpture, architecture, where time is "out of the question," are less useful this way. Not that we don't try. In a painting, the challenge would be to show how one event follows another, how to show cause and effect on a single canvas, how to tell a story. Artists from the beginning have experimented with a variety of solutions.

The easiest approach of course is the filmmaker's. You take a great many still photographs and then lay them (metaphorically) side by side so rapidly as to create the illusion of a seamless narrative flow. The art of cinematography, you won't be surprised to learn, is only tearing a page from the solving wit and dexterity of our very earliest artists, the cave painters at Lascaux, the Egyptian hieroglyphic storytellers. Explore any medieval collection and see if you can't find some version of a saint's "biography," where the continuity of a life is suggested in the juxtaposition of so many individual panels. Jesus' birth, the sermon on the mount, the crucifixion: these would be laid out, often enough consecutively on panels, to suggest an intelligible course of events, a biography of first to last. Folding diptychs and triptychs, with their conspicuous "hinges," are naturally conducive to any idea of human life as divided into discrete stages, stills in sequence.

There is a slightly more audacious solution that you see from time to time in the art of all ages. You intentionally underplay

the logic of space by painting scenes from a single life on a single undelineated canvas. Consider the Boccaccio painting below, "Scenes from the Life of Adam and Eve." Even here, notice, the depictions of creation, fall, and exile are parcelled out into sequenced quadrants. But what interests me is Boccoccio's insistence on not dividing these quadrants into distinct panels, as

Giovanni Boccaccio, *Scenes from the Life of Adam and Eve*,
Miniature from *De Casibus Virorum Illustrium*, 15th Century.

he could easily have done. Indeed, the scene of God's creation of Eve from the rib of Adam is so close to that of their fall, that the fallen Adam's foot is almost treading on the robes of his creator. It is the same garden. The scene of exile occurs in the foreground, almost counter-intuitively, where you would expect events to be receding away from a first instant (though perhaps the sense of the couple's coming nearer to the viewer as time passes has a logic of its own). The fallen world (presented as a kind of "day on the farm") appears in the lower right, almost in a space of its own (you have to pass out of Eden's arch to get there, but the brown building belongs to both worlds).

The audacity makes the simple, unapologetic, and rather radical point that these events from a single life are simultaneous. Not that we get hopelessly confused. We can still make sense of what is happening here, where spatial separation as usual *stands in for* temporal separation. But at the same time (at the same time!) everything here is happening *all at once*. I like to think of this sort of revelation as simply paradoxical, that we are related to ourselves, at one with our own presence, and leave it there. All the moments in your life are metaphorically a single moment. You sitting here now holding this book are beside yourself, *beside* yourself as a child, beside yourself on your death bed. Your body is quite actually going nowhere and has travelled no farther away from itself when you were born than any mountain could. Einstein's theory of relativity, with its implication of a "block universe," tells us that this is simply a material fact. Metaphorically, we also feel that we are related to the children we once were, not as a large stone is to a smaller one, but as a ball of string is related to the start of itself (the original "end"!) now buried deep within it. You are the same string and everything you are and have been is wrapped round and round inside you.

We tend to live as strict materialists: if a thing is here, it can't also be somewhere else. Quantum Physics suggests otherwise. The medieval artists were the quantum physicists of their day. If the saint is "here," the fact of his also being somewhere else *in his own life* is a matter of pictorial probability. It is also, of course, exactly how a god might perceive our lives unfolding in time as a

single—and also progressive—simultaneity. Northrop Frye wrote that in the strongest secular sense God is "unified perception." It may be that with narrative art forms so dominant now, we lose this sense of an unfolding immediacy. Not to get idealistic about cognitive abilities enabled by the internet, but there is something like the same principle at work there. On whatever page you find yourself, you can usually link to every other page, so that you can follow a narrative and yet still be "beside" where you started. The artists of Lascaux saw it first.

Thinking about Thinking

Standing in front of a painting in a gallery is primarily a mental experience, though the mind's body and the body's mind are involved too. The moment is different from looking at a television or staring into an iPod. But they are similar in this simple sense: in all cases, the mind is *drawn out,* drawn towards something beyond itself. We like having ideas and feelings, cognitive experiences of all sorts. It is quite possible that all experiences, even orgasms, finally reduce to neuron synapses and what they *feel like* to us. Blake wrote that body is that portion of mind perceived by the five senses. This book is about nothing if not how the mind is stimulated, how it will plunk its body down in front of things—a sports event, a music concert, a wedding, a natural wonder—in order to feel awake. It is the respite we seek from whatever dulling routines leave us falling asleep at the switch. We take ourselves out and we go before. Indeed, it may be that it is the simplicity of the gallery encounter—here a mind, there an object that catches its attention—that makes it so attractive to us, so *pronounced.*

One of the last frontiers in human understanding, as mysterious to us still as the causal origins of the universe and the quixotic math of Quantum physics, is the experience of consciousness, our sentience, our happening-inside-ourselves. How do we experience the experience of experience? How do we see our seeing? Cognitive philosophers are hard at work on the "hard problem," as some call it, of conscious subjectivity. Some of these thinkers hold to a traditional and familiar idea of consciousness as a "Descartian theatre," the idea that there is a little homunculous "you" inside you, watching your thoughts

happen "on a screen," as though it were an audience. Without this inference, these philosophers say, without the presence of this observing *je ne sait quoi* inside you, you would be nothing but a zombie, no more capable of real consciousness than computers are.

Not so fast, says Daniel Dennett, one of the leading cognitive philosophers in the United States, author of *Consciousness Explained* and *Sweet Dreams*. Clearly, we are not zombies. At the same time, the subjective experience of a "little you" inside you, he writes, may turn out to be an illusion, an effective one to be sure, but one that can be reduced to very real material effects in the brain. The "watcher" over our own thoughts may be an illusion that thought creates for itself as a kind of functional hypothesis that does useful work. It all makes fascinating and often very moving reading, and has much to say about our experience of spirit and imagination. A lot appears to be at stake, from the existence of the soul to our own personal freedom and self-determination. Where the mind and the brain are concerned, some fear throwing the baby out with the bath water. I think we have, quite actually, nothing to lose.

At the same time, the reflections of this book may provide us with further frames of reference for the debate. Where the experience of consciousness is said to be like the experience of an observer looking at something, it's hard not to think of the gallery moment, one person and one painting. The gallery room is your mind. The painting is a thought you are having. You are you, the one who looks at it.

Representations of consciousness are not unknown to painters. Exhibit one, Del Biondo's *Vision of St Benedict*, a painting that I have daydreamed over many times in my visits to the Art Gallery of Ontario. As a master chef, Del Biondo knows how to combine primary ingredients:

 1) A rock for nature;
 2) a shelter for our human dwelling;
 3) a man to step out from under the shelter;
 4) lots of light for the man to see;
 5) shake well and let stand for six hundred years.

Momento: On Standing in Front of Art

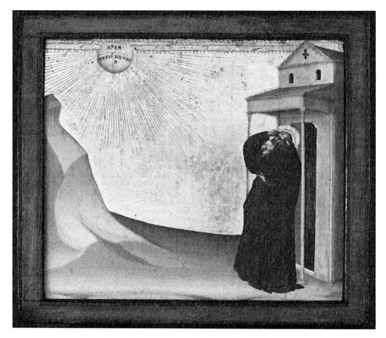

Giovanni del Biondo, *Vision of St. Benedict,* 14th Century.

Look at how much gold there is in the painting. Gold tooling, applied leaf by leaf in a painstaking and often expensive process, was quite common in medieval art. Crowns, thrones, the abstract background spaces behind Virgin and Child. In del Biondo's painting the gold stands in place of what would otherwise be part of the natural setting between the house and rock, hills and trees, a blue sky beyond. There is something quite actually *overwrought* about it, as St Benedict himself must have been by the vision he was having. This is not so much an actual sky as a state of mind.

St Benedict is evidently having a vision. The way he's holding his head, you can tell this is a pretty serious mental experience. What else would an apocalyptic revelation look like? Gold skies ablaze, emanating from a divine source. Actually, the source of the divine revelation seems to be partly the question. Whose gold is this? There are two spheres in the painting, the godlike sun, and St Benedict's noggin, both with

halos of gold around them. One is above, one is below. They seem to be related, possibly versions of one another. But St Benedict doesn't appear to be stepping out into an extension of his own mind—how would it look if he were? As far as he can see, it is the light of God objectively revealed to him. At the same time, those gold skies are not just the rays of an object-sun projected onto an object-earth. It is the presence of God's mind itself, made manifest to St Benedict, who has *the presence of mind* to see it for what it is. You can stand in front of this del Biondo and feel dizzy with the implication. Our consciousness is both consciousness of something outside ourselves, like rocks and light, and a consciousness of itself as such. St Benedict's revelation is a consciousness *of* God, a consciousness of someone or something "over there." But it is also his own consciousness: the consciousness of God in the subjective genitive, the human consciousness that God is. Consider that if God, as some believe, is a metaphor for consciousness itself, then the highest consciousness would be consciousness of consciousness.

Exhibit B. Fast forward to the impressionists, those pre-modern harbingers of Freud, dredgers of subjective experience. Monet's *Water Lilies* are at the Musée de l'Orangerie in Paris. You walk into those rooms like a St Benedict, hand to your head, bathed in a painted light: long curving walls a-swim in depths and surfaces of colour, dark purples winding in among dissolving blues on blue, green and yellow daubs of water plants with hints of red floating over and through the dissolving whites of deeper down cloud reflections. Mind and its iridescent behaviours are once again *in your face*. Indeed, what sometimes strikes me is how medieval the work seems in its apperception of a whole, a flushing-out into everywhere. Apocalyptic mind.

One telling difference. Del Biondo's landscape is a manifestation of God's mind that St Benedict walks out into and finds revealed. He is a part of it. Monet gives us, on the other hand, not the imagination's version of a god's mind that the viewer walks out into, like a saint. There is no viewer painted into the picture, only what the viewer sees. It is the perspective of the individual mind that God has now become. Where St Benedict stands at the centre of a god's apocalyptic reality, Monet, turning

the world inside out, shows us the same reality—the play of water and sky—as a god himself would see it.

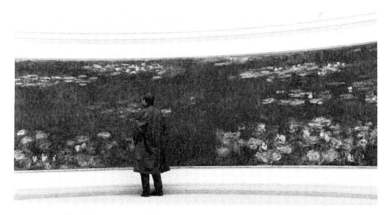

Claude Monet, *Reflets Verts*, 1914-26, with Author, 1991.

The debaters over consciousness will not be reporting to us any time soon with a consensus. In the meantime, I like to think of how our standing in front of paintings can remind us of the stakes involved, which includes something of our own unique *address* to the experience. As you stand before your del Biondo or your Monet, having thoughts about what you see there, you are a little like that audience member in the Cartesian theatre of consciousness watching your own thoughts pass before you. At the same time, the idea that you are watching anything pass before you at all may be an illusion. If the gallery space is your mind as a whole, with you standing in front of pictures of your thoughts, then you are just one more of its contents not to be distinguished from the pictures themselves. Which is to say that you are both: like del Biondo's St Benedict, you are the leading actor in the revelation of your own objective "you"; and like Monet's absent divinity, you are a swim of dazzling reflections, almost unreal, standing witness to their own uncertain depths and surfaces. Either way, it's in your head.

Fictions Among Fictions

I'd like to read a book on exemplary visits to art galleries and museums in literature. In Edith Wharton's novel *The Age of Innocence* (1920), Nuland Archer and his great but unpossessable love the Countess Elenska steal a rendezvous in the Cesnola Collection of Cypriot Antiquities at the rather new Metropolitan Museum of Art. The Cesnola collection, our narrator notes, "moulders in unvisited loneliness," such that our lovers can go there to be alone.

> She stood up and wandered across the room. Archer, remaining seated, watched the light movements of her figure, so girlish even under its heavy furs.[...] His mind, as always when they first met, was wholly absorbed in the delicious details that made her herself and no other. Presently he rose and approached the case before which she stood. Its glass shelves were crowded with small broken objects -- hardly recognisable domestic utensils, ornaments and personal trifles -- made of glass, of clay, of discoloured bronze and other time-blurred substances.
>
> "It seems cruel," she said, "that after a while nothing matters . . . any more than these little things, that used to be necessary and important to forgotten people, and now have to be guessed at under a magnifying glass and labelled: 'Use unknown.'"

The museum provides a symbolic setting of sorts, an appropriate commentary on the seemingly trivial, yet at the same time deeply felt, yearnings of the protagonists. Museums can make rather convenient settings for "fictional" encounters. Where better to reflect on the strange reality of fictional worlds and all that they make desirable, than to have fictional characters themselves go to a place where they are surrounded by just such fictional creations as themselves. It is as though the characters

for a moment were somehow *at one* with the artifice that makes them possible. They appear as but one example among others of the human creative act that is all the more elusive the more they try to move within it. It is what the Countess sees in the small curios under glass. Like her, they seem filled with a desire that comes of their not being any more than they are, or any less. The possibility of a fulfilment lingers in the room and its contents; but its elusiveness walls them in.

But Wharton doesn't leave us there. Years later, after Archer (spoiler alert!) has been separated from the Countess for decades, he has a chance to see her again in Paris. Before deciding not to pay his call, he once again visits a gallery:

> He got up and walked across the Place de la Concorde and the Tuileries gardens to the Louvre. She had once told him that she often went there, and he had a fancy to spend the intervening time in a place where he could think of her as perhaps having lately been. For an hour or more he wandered from gallery to gallery through the dazzle of afternoon light, and one by one the pictures burst on him in their half-forgotten splendour, filling his soul with the long echoes of beauty. After all, his life had been too starved.[...] Suddenly, before an effulgent Titian, he found himself saying: "But I'm only fifty-seven —" and then he turned away. For such summer dreams it was too late; but surely not for a quiet harvest of friendship, of comradeship, in the blessed hush of her nearness.

Archer is talking about the Countess here, but also about the very symbols of unconsummated love in the paintings themselves. Like him, fictions. Like him, both there and not there. As he returns to "the very place," he senses the blessed hush of a nearness.

I Seen the Little Lamp

In August of 2011 I went with my daughter Cory to visit the Victoria and Albert Museum of Childhood in London. The grand open market style building was constructed in the 19th century originally to house some of the overflow exhibits from the Great Exhibition of 1851. The building is one enormous room that you can look down into from the second- and third-floor mezzanines that circle it. Our particular goal was to take in the magnificent collection of dollhouses. Some were as tiny as cigar boxes, some taller than ourselves.

I am instinctively drawn to little imaginative worlds, dwelling places. Be it a painting, a sculpture, a poem, let the piece confront me with the question of "where do you want to live?" and let it seem to recommend itself, however metaphorically or elusively, as just such a space in which to dwell—dwell in, or dwell on—and I am helpless. My mind throws a pair of make-believe pajamas into a make-believe suitcase, and I'm off.

We dwell in spaces that are large enough to contain us and try to make ourselves at home there. We move our furniture in, set our things about, tailor the layout of the rooms to suit our needs and reflect our individual personalities, our work, our desires. "Dwell" is a marvellous old Anglo-Saxon verb, with seasoned and venerable Germanic roots in *gitwelan* that lead all the way back to Sanskrit *dhwr*. Its original denotation was "to lead into error or delude." The word ping-ponged around inside notions of holding someone up or delaying them, before coming to rest in our common sense of staying or abiding. You can see how easily the word might have divided into its physical and cognitive senses. You can dwell *in* a place, but you can also

dwell on something, which is to say carry your thoughts off in a holding pattern and become waylaid there. I'd also like to think that something of the *wandering way* still dwells, if you will, in how we shelter in imaginative places.

As you move among the doll houses at the Museum of Childhood, you can't help but feel the same intuition everywhere. Each little building says "I am a dwelling place. I am open to you. I hide nothing." Its blatant openness cannot help but beg the question of your *entering there*, where you are invited to come in, as it were, *through the back door*, surreptitiously or with the kind of informality reserved for closer family and friends. The mere existence of the house, as with most poems or paintings, is an invitation. Come in. Make yourself at home. But as with all imaginary places, of course, there's a complication. You're too big, normally twelve times as big as the standard dollhouse. Something as small and dextrous as your hand can wreak havoc in this fragile domain.

There is plenty of good writing on the hermeneutics of the doll house. Susan Stewart offers a fine discussion in her book *On Longing*, and Robert Harbison dwells on the subject in his *Eccentric Spaces*. I read an article years ago in the old *Grand Street*, "The Fascination of the Miniature," that has stayed with me. With doll houses and other miniatures, you feel both an ache and a thrill: you are master of a world that you are also excluded from. It is the perspective of a certain kind of god. You are free to move things around, arrange the furniture if you like, even set the puppet-like family figures where you would have them. You can stand back and take it in. But, like a mere secular giant, you cannot enter. You are too outsize, too other to move about in the spaces that you have created. The very essence of bittersweet: a feeling of total comprehension on the one hand, and an unfulfillable longing to be *admitted* on the other. It seems no wonder that Christianity includes a god-man who could, in a moment of miraculous intervention, walk in through the front door of the little place God had made and tell everyone there what you would see if you could see everything whole from the outside, as his father does. The world we live in, of course, with a god peering in through its windows, is that same doll house

turned inside out, though our front and back doors are not as easy to find.

To dwell inside a world is to be contained by it. To be contained means that you don't see it from the outside. That is, the ironic perspective of detachment is specifically excluded. Exclusion is the price you pay for the perspective you gain when you "move out" and see the whole for what it is. But, of course, in another equally important sense, we are not excluded. There is a particular form of dwelling that the doll house is in every sense open to. You move around inside simply by looking. The eye is the most capable of inhabitants, the freest and most lighthearted. It can go about room to room, take in every least particular, the tiny pictures on the wall, the minuscule fireplace bellows beside the hearth, the cradle upstairs, the cans of food on the kitchen shelf. Your eye moves about there like an invisible spirit, here picking up the vase of flowers on the table, turning it about, there passing noiselessly up the winding stairs into the gabled attic.

Looking is a kind of *visionary* dwelling. I can't *really* go in there, you say. It is only a plaything after all. But the eye *goes before*. It goes on ahead to test unknown or unexplored territory. It is reconnaissance. "Is this somewhere I could live? Would I be happy here? How would I move about, what routines, what order would I enjoy?" It is the poetics of Utopia in miniature. The eye stirs about, looks down into the stairwells and peers out through windows. It moves alone there, almost as a ghost might, invisible and discreet, comes to know the place and sizes it up, all in the service of deciding whether it would be safe to come nearer. Back outside, the body waits, listens for an all clear.

Every painting is a dollhouse in this sense. Every Grecian urn or Roman coin. You look at it from outside. You peer in through just so many "picture-windows" that give onto its own depths and look down the long dim corridors of its historical moment. There is a stairwell at the heart of that Constable landscape; you go to the foot of it and call out a timid "Hello?", listen for reply. There is an upper room in that Rembrandt self-portrait. It seems to you that it must be quieter there, more softly lit. Funny that no stairs lead to it; but no matter; to see it at all is to know how to get there. The stone arrowhead from 10th century

Momento: On Standing in Front of Art

Ontario BCE, the ivory comb from dynastic China, the miniature 17th century Dutch seascape with boat masts tiny as hairs in the grey distance: each is a created world. You stand apart from it, but your seeing it at all is a looking ahead of where you are, a being on the verge of entering.

Katherine Mansfield gets at the heart of all this more succinctly and beautifully than I can manage. In her short story "The Doll's House," the Burnell children receive a magnificent doll house as a gift from dear old Mrs. Hay. They become instantly popular in the neighbourhood as friends jockey about for the right to see it first, to have the back portion of the house opened up so that they can look in. Inside the sumptuously furnished and intricately detailed miniature home stands a little lamp:

> It stood in the middle of the dining-room table, an exquisite little amber lamp with a white globe. It was even filled all ready for lighting, though, of course, you couldn't light it. But there was something inside that looked like oil, and that moved when you shook it.
>
> The father and mother dolls, who sprawled very stiff as though they had fainted in the drawing-room, and their two little children asleep upstairs, were really too big for the doll's house. They didn't look as though they belonged. But the lamp was perfect. It seemed to smile to Kezia, to say, "I live here." The lamp was real.

Mansfield plays ingeniously on the crucial question of who belongs there. The dolls themselves appear out of place in that world, too big for its rooms, as we ourselves would be. From our ironic perspective, the privilege of belonging there is tied up with the question of who gets to look inside. It is, of course, a class issue. The working-class Kelvey sisters—"Lil" and her younger sister "our Else"— are not allowed to visit; they are "out of the question." The story cries out in bitter protest.

One thing that does seem to belong in the house is the lamp itself. Of course, none of the more privileged children "sees the light" that is there for them to see. None but Kezia Burnell, the youngest of the family, who, as Mansfield's surrogate in the story, appears to understand the imaginary place and its genuine reality, a place where there is room for all, could they but see the little source of light that illuminates it at the centre. The allegory

unfolds swiftly to its climax. When there appears to be no one around, Kezia sees a chance to show the Kelvey sisters the inside of the doll house:

> "There it is," said Kezia.
>
> There was a pause. Lil breathed loudly, almost snorted; our Else was still as a stone.
>
> "I'll open it for you," said Kezia kindly. She undid the hook and they looked inside.
>
> "There's the drawing-room and the dining-room, and that's the-"
>
> "Kezia!"
>
> Oh, what a start they gave!
>
> "Kezia!"
>
> It was Aunt Beryl's voice. They turned round. At the back door stood Aunt Beryl, staring as if she couldn't believe what she saw.
>
> "How dare you ask the little Kelveys into the courtyard?" said her cold, furious voice. "You know as well as I do, you're not allowed to talk to them. Run away, children, run away at once. And don't come back again," said Aunt Beryl. And she stepped into the yard and shooed them out as if they were chickens.
>
> "Off you go immediately!" she called, cold and proud.

The Kelveys dash off up the road and sit together on a stone wall, alone once more. Master storyteller, Mansfield finishes with a beautiful and discreet summary of all that is at stake in any visitation where we stand before inner worlds that are not our own, from which we are excluded for whatever reason, and whose lights illuminate ways we might yet travel could we but see them for what they are:

> Presently our Else nudged up close to her sister. But now she had forgotten the cross lady. She put out a finger and stroked her sister's quill; she smiled her rare smile.
>
> "I seen the little lamp," she said, softly.
>
> Then both were silent once more.

The Little Patch of Yellow Wall

"The Death of Bergotte" scene in Marcel Proust's *Á la recherche du temps perdu* surely represents one of the great "encounters with art" that we have in modern literature. Along with the bedtime kiss and the memory-stirring madeleine dipped in tea, it has a stand alone quality among the three thousand pages of Proust's epic. For Proust, art is the bitter alembic in which the solutions of redemption and revelation are measured out and mixed. His work represents the demands we make upon our own restorative powers in creativity, where our many suffered losses and gains come to bear on fleeting experiences that are in every deepest sense bittersweet. Proust's novel is nothing if not just such an encounter writ large. It is the gallery in which he will approach, in the guise of one of his characters, the measure of his own work and what he hoped to achieve in it. In the scene of Bergotte's death, Proust will discreetly confess his own indebtedness to the many artists, like his beloved Vermeer, who become present in the novel in the form of just such "visitations" as this.

The scene is instructive. The ailing novelist Bergotte insists on a visit to the Louvre to see a Vermeer exhibition, especially his celebrated *View of Delft*. His health is precarious; it seems to be this very sense of an impending end that compels him to go and stand before a single canvas where he will confront all he has been and done and weigh it in the balance.

> Finally he stood before the Vermeer, which he recalled as more dazzling, more unique, but where, thanks to the article he had read, he noticed ... several little characters in blue, the pink sand, and finally, the prized substance of a small patch of yellow wall. His vertigo worsened; he fixed his gaze, like a child following a yellow butterfly it wants to catch, on the tiny bit of wall. "That's

how I should have written," he said. "My latest books are too dry, I might have added one or two layers of colour, rendered the language itself beautiful, just as this little patch of yellow wall." All the while, he was not insensitive to the seriousness of his condition. He saw before him, as on a pair of heavenly scales, his own life weighing down on one side, and on the other, the beautiful little patch of wall painted in yellow.

Bergotte mouths the phrase to himself again and again: "Little patch of yellow wall, with an awning, little patch of yellow wall." Suddenly he sinks under one stroke (of fate?) and then another, and dies there and then.

Johannes Vermeer, *View of Delft*, 1661.

The two pans of the scale are reproduced in the moment of looking, with the painting on one side, and the ailing Bergotte standing before it on the other. The notion of a Last Judgment has different meanings for different people, but for a secularist like Proust, interested in the redemptive potential of art, Bergotte's whispered confession could only represent, for the narrator Marcel, a judgment upon himself. The space between Bergotte and the painting begets a quite actual, fatal, apocalyptic crisis,

the ultimate separation at the end, among the artistically faithful, of the saved and the damned.

I think if any painting could have the power to kill a person right then and there, it might be a Vermeer. There are no health warnings hung beside the great art works. "Visitors with a heart condition or asthma should refrain from gazing at this Holbein portrait for too long." Seats with seatbelts in front of a Jackson Pollock? Can art have this sort of impact? Could anything like this happen to the rest of us? A life crisis in a museum? A metaphor for the power of metaphor. Could you wander up to an Egyptian comb and feel ashamed of yourself? Could you contemplate a Ming vase, terrifying in its jeweller's-eye detailing, and slump to the floor? "I should have lived my life and gone about my routines as though I were adding a brush stroke to a little patch of yellow wall, as unreal as my own days have felt, yet as burnished with a bittersweet longing to make it my own."

Critics do not agree on where this little patch of yellow wall actually is in Vermeer's *View of Delft*. There appear to be several candidates, none of them wholly satisfactory. Is Proust playing a trick on us, leaving us to go looking for the elusive detail that seemed to have eluded Bergotte himself? We become living Bergottes in corresponding scenes brought to life every time we visit a gallery. We move from painting to painting and look to be struck by the kind of revelation that the ailing writer himself experienced, unsure of where it might hide in the end.

One last note. Proust's housekeeper and confidante Céleste Albaret writes that the author himself had stood before Vermeer's *View of Delft* near the end of his life. In the spring of 1921, he went with a friend, the writer Jean-Louis Vaudoyer, to an exhibition of Dutch landscape paintings at the Jeu de Paume in Paris. Albaret also remarks that Proust made one or two revisions to his manuscript on the last day of his life. No more, surely, than a few light touches, a little patch of yellow wall.

You Leave

The Gift Shop

Time is winding down. You're feeling tired. There is a sense now that you've stopped looking. The heaviness of your body is the fullness of your mind. You think about destinations again. Your eyes go to halls and doorways. But there is one last stop. The gift shop that you passed by when you arrived looms large at the exit. In the gift shop, you are already back in the old world: the bustle, the line ups at the cash, the getting and spending. Laughter. A sizing up of garments. The gift shop is in some ways an affordable replica of the museum itself: the postcard copies of paintings, the plaster casts of statues, the faux Egyptian jewellery expensive enough to give it value. The museum for sale, the museum as it exists in a world of capital.

There is an attitude in visitors that one finds more often in the gift shop than in the museum proper. The sense that we are looking for something. In the museum, we are just looking, not so much *looking for*. The atmosphere of detached, even cool observation pervades most gallery rooms. But you sense a change of movement in this room, searches, a purposeful rooting about: something nice, a small object, a book or a postcard, a stone, a game. We are curious and vaguely excited. What will I find here? What will I take home?

The shops go by different names, but are usually thought of as "Gift Shops," less often "Souvenir Shops." You would find a "gift" for someone who wasn't there, and you would find a "souvenir" for the one who was there and wants to remember it. What if the two were indistinguishable? What if we visitors were the ones who for the most part "weren't there"? We would need to go to the gift shop to buy something for ourselves. The

things we buy would say funny things like "A small part of my attention went to the gallery and all the rest of me got was this lousy t-shirt." The old pun rears its head: we buy presents to stand in for presence.

There is a less cynical way of looking at ourselves there. Come back to the original question. What are we looking for? We are looking for the gift shop. The shop that makes a gift of what has happened to us. Nothing we see in the museum is for sale. Yet everything we see there is an offering. Everything you have thought and felt, because you cannot buy it ("your money is no good here"), is a gift of sorts. Just as a postcard represents an original painting, so the gift shop represents the original gift of the museum itself. The museum rooms become a single room. Its givens and holdings forth, stay here as they may, are for you. Take them. It is the thought that counts. And so perhaps you don't need to buy anything at all. You already have your gift, and it is already a souvenir.

Street Crossing

There are various ways of coming full circle during a gallery visit, some of them more obvious than others. For one, we're back at the entrance; we have stood here before in our wanderings. But I want to come back, full circle, to an original theme as well. I said at the outset that we resembled figures from a George Segal sculpture (cf. 6). Segal's plastery pedestrians can be seen here and there in public. I saw a brilliant tableau of his in the Port Authority Bus Terminal in New York. A row of three plaster commuters stand in a line in front of a real doorway, looking bored to sods. I must have been the thousandth person to join them (who could resist?) and have myself photographed as a self-styled real person at the end of the line. If you're going to be oh-so-realer-than-thou among these ordinary, yet otherworldly markers of time, then you must—whatever in heaven's name *this* is going to mean—wait your turn. I tried to look as impatient as I could for the line (Oh man, come on!) to get moving. It was art's imaginary train somewhere above them that I thought of just then. It would never be boarded.

Segal understood how effortlessly actual and imagined worlds could be turned inside out. The cast of his *Street Crossing* that we saw earlier on page 6 appears inside a gallery, but other iterations have been placed in just those public squares and actual street crossings where they seem most at home. Transported to a gallery interior, do these hollow drifters make you feel uncomfortable? You the plain-etched? You the rough-cast wanderer? You the directionless? That old (gender-biased) expression "the man in the street"—any Tom, Dick, or Harriet— weighs heavily on you. You could be anyone, quite actually, and

you carry your ordinariness, even into strange worlds, like an immovable fact. No getting away from it.

But not so fast. When set indoors, Segal's "Street Crossing" makes a further point. These outdoor people, without changing at all, seem now to be wandering like us in a space where everything has meaning and *gives* meaning to any indifferent step. Every movement is movement *towards*. Is it true of us as well? Do we change in our essential minds and hearts in merely finding ourselves in a curious place? You enter a museum and become suddenly other? Now it is our very *having no direction* that becomes a centre of gravity—we plaster daydreamers—an allowance or a permission. We become the needle in a compass, just for having coordinates spun out all around us.

I suppose it is Segal's genius that, according to how his sets are placed, reminds us of two plain truths that we never escape. The outside real world, as we call it, is permeated with imaginary presences that point out to us an aspect of make believe that follows us everywhere. Meanwhile, galleries and museums— inside worlds of made-up things—become all the more real for having everyday momentums activated in their midst. So move at your ease, dear visitor, even as you leave. Everywhere you go, there will be a crossing.

Way Out

Art Gallery of Hamilton.

Often when I visit a museum with my children Miller and Cory, I ask them as we leave the building and go out into the street noise: "What was your favourite part? What do you remember most?" I listen for the pause that hangs over us an instant before their sometimes eager, sometimes sleepy answers. That pause, it seems to me, is the museum.

It's late afternoon now. The cobalt blue dusk of Southern Ontario. The air is clear and nippy. There is almost something giddy and welcoming about the scrimmage of taxi cabs and pedestrians. They are actors from a movie starring themselves, exhibits at a gallery, pictures of what the world is like. You pass before them, a restaurant, a tax office, a factory, a boutique. We

could go through their doors and there would be rooms with things in them. How strange to see them now. The menu in the restaurant window, a prophecy of secrets. The tax office, a Cornell box of whimsical doodads. I would want to stand back and applaud.

Joseph Cornell, *The Hotel Eden*, 1945.

My friend Alvin Lee, Anglo-Saxon scholar, former president of McMaster University and benefactor of the library and museum there, once told me a story of a conversation he had had with a potential corporate donor he was hosting. They were talking about the value of the arts. "Problem is, Alvin, you folks here don't live in the real world." Alvin paused a moment. "I'm not sure," he replied. "When I think about people on their couches, sleep walking through two hours of 'reality television,' brokers selling unreal futures, discount superstores filled with aisles of imported plastic junk destined for the land fill next month, I have to wonder where the real world is."

Standing in the doorway of the museum, I face out into the most expensive installation ever made and one of our greatest fictions, that the world we spend most of our time in is the *real* world. It seems so hastily thrown together, so tentative, a work in progress. I think the artist might have been having a bad day. But I think, "this is what the world must look like to a painting."

I step out onto the sidewalk, turn around, and look at ... a momento. Let it be what it will. The Art Gallery of Hamilton, inviting glass, banners big as life. Or the little municipal museum down the road in Grimsby, a house among houses. Or the Uffizi in Florence, visible for miles outside the city. Or a collection of empty bowls from ancient Greece. Or the little kitchen scene of dollhouse furniture, arranged just so on my kitchen counter, for friends to look at and recognize, just for seeing it, where they truly live.

Works Cited

Albaret, Céleste. *Monsieur Proust: Souvenirs recueillis par Georges Belmont.* Éditions Robert Laffont, 1973, p. 404.

Auden, W. H. "The Cave of Making," in *About the House*, Random House, 1965, p. 8.

Bishop, Elizabeth. "The Map," in *The Complete Poems 1927–1979*, Farrar Straus Giroux, 1983, p. 3.

Davenport, Guy. "Robot." *Tatlin!* Johns Hopkins University Press, 1974, p. 88.

Huizinga, J. *Homo Ludens: A Study of the Play-Element in Culture.* Routledge, 1949, p. 166.

Huysmans, Joris-Karl. *L'art Moderne.* Librairie Plon, 1883, p. 113. Trans. Jeffery Donaldson.

Mansfield, Katherine. "The Doll's House." Selected Stories (Oxford World's Classics). Oxford University Press, 2002, p. 351 & pp. 355-56 & pp. 356.

Millhauser, Steven. "The Fascination of the Miniature." *Grand Street* 2:4 (Summer 1983), pp. 134-35.

Pliny the Elder, *Historie of the World*, Vol II. Trans. Philemon Holland. London: Printed by Adam Islip, 1601, p. 496.

Plutarch, *The philosophie, commonly called, the Morals* (transl. Philemon Holland). London: A. Hatfield, 1603, p. 141.

Proust, Marcel. *À la recherche du temps perdu*, Vol I. Éditions Gallimard, p. 139. Trans. Jeffery Donaldson.

Proust, Marcel. *À la Recherche du Temps Perdu*, Vol III. Éditions Gallimard, pp. 187. Trans. Jeffery Donaldson.

Stevens, Wallace. *Opus Posthumus*. Random house, 1957.

Wharton, Edith, *The Age of Innocence* (Oxford World's Classics). Oxford University Press, 2006, pp. 216-17 & p. 251.

Illustrations

George Segal. *Street Crossing*, 1992, Plaster, paint, 72 x 192 x 144 inches. Courtesy of The George and Helen Segal Foundation, New Jersey, and Carroll Janis, New York.

Pococke, Richard. "Plans of the Temple and Other Buildings of the Labyrinth. " *A Description of the East, and some other Countries*, Vol. 1. London, W. Bowyer, 1743. Aikaterini Laskaridis Foundation Library. Public domain.

Giuseppe Castiglione. *View of the Salon Carré in the Louvre*. Musée du Louvre. Public domain.

Alexander Cozens, from Plates 1-16 ('blot' landscapes) for "A New Method of Assisting the Invention in Drawing Original Compositions of Landscape," Plate 2. Image © Tate.

Caspar David Friedrich, *Wanderer Over the Sea of Mist*, 1817. Hamburger Kunsthalle. Public domain.

Sandro Botticelli, *The Annunciation*, 1485. Metropolitan Museum of Art. Public domain.

Pierre Bonnard, *Scène de Rue*, 1894. Fondation Bemberg. Public domain.

Torso of Eros, 3rd – 2nd Century BCE. Royal Ontario Museum. Image © Jeffery Donaldson.

Lascaux Cave, Montignac, Dordogne. Public domain.

Egyptian Model Granary. Royal Ontario Museum. Image © Jeffery Donaldson.

Élisabeth Louise Vigée Le Brun, *Self Portrait in a Straw Hat*, 1782. National Gallery, London. Public domain.

Lawren Harris, *North Shore, Lake Superior*, 1926. National Gallery of Canada. Image © NGC.

Auguste Rodin, *Honoré de Balzac*. Musée Rodin. Public domain.

The Story of Adam and Eve, detail from "Cas des Nobles Hommes et Femmes, " by Giovanni Boccaccio (1313-75) translated by Laurent de Premierfait, 1465 (vellum). Image © Art Resource.

Giovanni del Biondo, *Vision of St. Benedict*, 14th Century. Art Gallery of Ontario. Public domain.

Claude Monet, *Reflets Verts*, 1914-26. Musée de l'Orangerie. Image © Jeffery Donaldson, 1991.

Johannes Vermeer, *View of Delft*, 1661. Mauritshuis, The Hague. Public domain.

Hamilton Art Gallery. Public domain.

Joseph Cornell, *The Hotel Eden*. National Gallery of Canada. Image © NGC.

Acknowledgements

I wish to recall my many debts in the formation, composition, and gestation of this little book. If it has presented itself as a kind of museum of knickknacks and curios, it is time to confess the obvious, that there is a further room—farther in and less easy to find for the casual visitor—that is the one I visit most: a portrait gallery of loved faces who have watched over and blessed my wanderings among them.

 I hope Peter Sanger has not forgotten how helpful he was to me when I showed him, more than ten years ago, some disorganized notes on visiting art galleries. He speaks with such authority in my life and his markups and caveats were invaluable. George Matheson and Tana Dineen, to whom this book is dedicated, helped me find my way back to the original intuition, that the psychological experience of the painting moment is worth exploring. May our conversations continue. If you need a book title tweaked, check in with Tana. Karen Schindler, truest partner with whom I visited most of the art I've seen in the past decade, knows where and how she moves among these pages. My friends John Terpstra, Bernadette Rule, Roy Adams, Alvin Lee, Luke Hathaway, William Blissett, John Reibetanz, William Aide, and Philip Wylie have watched out for me—shining graces—from their own solid frames. My sincere thanks to editor Shane Neilson and publisher Jeremy Luke Hill. Shane's portrait ought to be the first you see when you enter this room. He looks over and beyond. If you happen to be a manuscript, his eyes will follow you across the room.

 Finally, to my family, Annette Abma, Cornelia Abma, and Miller Donaldson—artists all—love and gratitude.

About the Author

Jeffery Donaldson is the author of seven collections of poetry including *Granted: Poems of Metaphor* (Fall 2022). *Palilalia* was nominated for the Canadian Author's Association Award for Poetry in 2008 and a prose work, *Viaticum: From Notebooks*, received the Hamilton Arts Council Award for non-fiction in 2021. Donaldson teaches poetry and poetics at McMaster University. He lives in Hamilton.